Noir Voyager

A Compilation of Film Noir Movie Reviews
from the Supervistaramacolorscope blog
and beyond.

by Mel Neuhaus

Noir Voyager
by Mel Neuhaus

Published by Cardinal Content

ISBN 978-1-877912-59-7

For Skiddie: Baby, you're the greatest!

They got it good for Mel and Noir Voyager:

"Mel Neuhaus is not only knowledgeable about movies, he *loves* movies, and that comes across in his articles. Mel is opinionated, funny, bitterly sarcastic (which is why we've been friends for so long), but he also has a fresh and joyful appreciation of acting, directing, writing, cinematography—even the film stock and score will get their praise (or pan) from him. He knew and interviewed many of the actors and directors he discusses, so we also get great behind-the-scenes gossip you won't find elsewhere.

If you can't go to Mel's house and have a Movie Night with him and his wife and pals, reading this book is the next-best thing. It's like a child's pop-up book, only with Mel Neuhaus popping up, entertaining and informing us about films we already love, and films we've never heard of."

--Eve Golden, author of *Platinum Girl: The Life and Legends of Jean Harlow; Vamp: The Rise and Fall of Theda Bara; The Brief, Madcap Life of Kay Kendall*

"Mel Neuhaus is the film historian's film historian. Reading his prose or sitting in his presence, one is entranced by his exquisite depth of knowledge, a professorial command of the names and faces that populate his field of expertise: the royal realm of vintage Hollywood. His most recent work, **Noir Voyager**, is a revelation-a-page treasure. Don't know Anton Diffring? George Zucco? Abraham Polonsky? You will, and all the better for it. *Noir Voyager* — hold it, savor it, return to it — a most satisfying and rewarding read."

--Patrick Galloway, author of *Asia Shock: Horror and Dark Cinema from Japan, Korea, Hong Kong and Thailand*

"Particularly well researched and enjoyably informative Mel Neuhaus has a witty turn of phrase that adds sharp headline comment and style to what always ends up being a thoroughly entertaining movie review. Supervistaramacolorscope. often tries to be all things to all viewers and regularly succeeds."

--Paul Brennan, *www.ptbscreen.com.au*"

"My buddy Mel Neuhaus knows noir—hell, the man knows genre, period, and he's been my invaluable answer man for obscure film questions for years. Mel's got more than knowledge: he's got impeccable taste, too. He combines all these qualities in these witty, passionate, compulsively readable web reviews."

--Glenn Kenny, Film Reviewer author of *Anatomy of an Actor: Robert De Niro* (Phaaidon/Cahiers du Cinema, 2014)

"**Noir Voyager** is a treasure trove of exceptionally smart, crisp writing about movies, fairly dripping with wisdom and wit. There's little resemblance between this volume and the multitude of verbiage on the internet passing for movie reviews. Mel has a knack for seeking out films that have fallen through the cracks; as a result, he's given me a lot of homework, catching up with pictures I haven't seen but clearly should."

--Jordan R. Young, author of *King Vidor's The Crowd* and *Reel Characters*

Introduction by Christa Lang-Fuller

If asked to choose a genre in cinema to pen an introduction for a book, I suspect it would undoubtedly be film noir. As an actress, I appeared in Godard's *Alphaville* (a semi-spoof) and Chabrol's *The Champagne Murders*. Mostly, I'm proud of being the *femme fatale* of 1973's *Dead Pigeon on Beethoven Street*, directed by the great Sam Fuller, who, BTW, was also my husband. We were the perfect film noir couple – noir being the ultimate American celebration of dark, sardonic brilliance embellished by a delicious abundance of German Expressionism (I was born in Winterberg, North Rhine-Westphalia, DE).

Sam and I first met in Paris, in 1965, where he was presenting his picture *Shock Corridor* at the Cinematheque Francaise. Sam went back to California, and nine months later sent me a one-way ticket along with a marriage proposal. We married in 1967 and collaborated on several late works. Our greatest production was released eight years later: our daughter was Samantha, a fine filmmaker in her own right (the documentaries

A Fuller Life and *Harumi,* and soon her first fiction film).

Very pleased to have been asked by Mel Neuhaus to write this intro. Mel's articles in Supervistaramacolorscope are totally fun celluloid excursions; aside from knowing his stuff, he genuinely loves movies – how they're made, who made them and why they're great. Mel's humor, which intertwines with his penchant for spinning fascinating facts and tidbits, is, too, of the dark variety, thus, again, perfectly suited to film noir. He intrigues us with obscure references that beg for readers to do a little research. I love that he doesn't "dumb down," demanding his fans do a little gumshoe work on their own. As my character in *Dead Pigeon on Beethoven Street* might remark to pissed-off novices unfamiliar with a certain forgotten title, song lyric, word play, etc., "Stop bitching, get off your ass and use your brains, if you're so goddamn curious!" Again, that's my character from the movie. I would NEVER be so rude and vicious or evil. Or would I?

--Christa Lang-Fuller,
June 2019

Foreword

We have the extreme honor of publishing this compendium of Mel's insightful and often outrageous reviews of selected film noir movies, (mostly) originally published on his acclaimed Supervistaramacolorscope blog. Though there are many ways to view and enjoy the instantly recognizable imprimatur of film noir movies, none is more satisfying as on High Definition Blu-Ray and DVD disc. Blu-Ray, in particular, renders exquisite images, superior audio, and leaves room for insights and interviews.

Mel takes it all to an ultimate level by highlighting the narrative of each movie (but never to spoilage), and the behind-the-scenes story of production; emphasizing the fascinating artists and craft folk who made these gems, often with severely limited budgets and in record time.

Indeed, the whole idea of "Black Film" comes directly from the dirt-cheap method of photographing scenes in limited settings, at night, with a minimum of lighting that not only saved time and money but gave the film a shadowy

foreboding that the plots and characters inhabited with precision.

The other canons of the genre include: the brave, imperfect, and cynical protagonist, who must turn to violence against the indomitable evil antagonist; the irresistible femme fatale who offers both redemption and destruction in a gambit to find her own justice; the ensemble of street characters; good and bad cops; the corrupted rich; the desperate poor; the unsuspecting everyday bystanders; all portrayed by some of the best actors and actresses in movie history.

Add in the aforementioned perfected black and white imagery, shot to be as evocative as the heart-and-guts thematics; all originating with superb writing often from or inspired by masters of twentieth-century American literature, and all helmed, as Mel's *Variety*-inspired vocabulary notes, by legendary directors who created works of art and an entire genre of the highest artistic merit.

Mel, furthermore, takes us "noiristas" (the first person the coin that term, by the way) into

veritable "uncharted territory" with his celebration of contradictory color-noirs, an offshoot that remains one of the author's favorite sub-genres. All of that and much more comes to life with each of Mel's reviews. And each review is written in an accessible and entertaining style, again inspired by the show-business lexicon that makes for engaging, easy-to-enjoy, and at times enthralling yarn of success, failure, inspiration, villainy, and more often than not outright genius.

Some of these reviews and articles have been updated and revised from their original appearance in

. Every title discussed has had a Blu-Ray and/or DVD edition release. Most of these pics are still available, but some, like the Twilight Time entires -- all limited editions -- may be out of print. Still, for those adventurous internet nomads, copies may be occasionally found online. The best source for any and all of these platters really is the actual studio/company that released them. Often, they have mammoth sales on the websites, sometimes offering as much as 70% off! Below is a list of the

home video companies whose product this volume reviewed. Check 'em out. You might be pleasantly surprised.

Kino-Lorber Studio Classics:
www.klstudioclassics.com/shop

The Warner Archive Collection: www.wbshop.com/collections/warner-archive

Twilight Time Movies:
www.twilighttimemovies.com/

Olive Films: olivefilms.com/

Film Movement: www.filmmovement.com/

Cinelicious: arbelos.bigcartel.com/products

Table of Contents

LEAN STREETS

When it comes to home video, no single retro genre is more profitable than film noir. These slick, nasty, amoral, atmospheric thrillers of hopelessness and madness have ruled the filmic roost (for VHS, laserdisc, DVD, Blu-Ray and revival houses) for nearly fifty years. But, as they say, "it's so old, it's new."

Indeed, with the fantastic successes of *The Maltese Falcon, I Wake up Screaming, This Gun for Hire* and others, all the studios went noir (before they even knew what it was). And that especially applied to the lower echelon sausage factories, aka Poverty Row. And why *not*? Look what you'd save on lights *alone*!

As for the majors, their "B" units went into overtime, cranking out quirky, unsettling crime dramas that tended to veer from mere greedy villainy to lust appended by a myriad of psychological disorders.

Thus, I have taken it upon myself to introduce some (mostly) obscure samples in this bargain

basement of unhealthy and nightmarish obsession, more commonly christened twentieth-century America (running the democratic gamut from Monogram to MGM). All are available as made-to-order DVD-Rs from the (God bless 'em) Warner Archive Collection, and are presented in excellent crisp 35MM transfers with above average audio to match.

MGM's 1942 **KID GLOVE KILLER** was a prime B-unit entry populated by soon-to-be A-list folks. Natch, anything "B" at MGM would generally pass as an "A" at any other studio. On Poverty Row, it would be DeMille.

KID GLOVE KILLER is a surprisingly progressive programmer that transcends mere "mystery" and dives headfirst into the sick, swirling, dark world that Dick Powell was always getting drugged/cold-cocked into (post-Busby Berkeley, that is); in short, more noir than detective filler. Of course, it helps greatly that, aside from the top production values, the picture has a superb cast and director. Helming this mini-gem is none other than Fred Zinnemann, graduated from his *Crime Does Not Pay* shorts and kicked upstairs

into the full-length-feature big time. Leading the cast as a top M.E. is the always terrific Van Heflin, one of his only "B" appearances, as he would be winning the Best Supporting Actor Oscar later that year (for the noirish "A" *Johnny Eager*). Marsha Hunt (still trucking today at 102) is the savvy, sassy smart associate Heflin appoints to assist him above the many male applicants (rather unusual for the time, especially for a "B"). Lee Bowman, likeable but ever-smarmy, is Heflin's BFF, a rising politico who, coincidentally, is also a cunning sociopath resorting to gruesome murders to pave his way for a vocational future in local government.

It's a wild and suspenseful ride watching Heflin and Hunt brilliantly resort to science to solve the crimes and exhibit disbelief at who the culprit turns out to be. And then there's Bowman, seducing both of them in friendship and romance (Heflin and Hunt, respectively; it's not THAT progressive). The story and screenplay by Allen Rivkin and John C. Higgins (from a story by Higgins) is a tense nail-biter, presenting an admirable blueprint for what would become a Zinnemann specialty (*High Noon, Day of the*

Jackal). Zinnemann and Heflin would be reunited at Metro six years later for the "A" *noir Act of Violence*, but, frankly, I prefer this little 74-minute thriller. The expert photography is by Paul Vogel, the lush score by David Snell (with uncredited help from Daniel Amfitheatrof and Lennie Hayton). The supporting cast is fantastic, and includes Samuel S. Hinds, Cathy Lewis, John Litel, Eddie Quillan, Leon Belasco, real-life gloveless killer-as-a-kid Bobby Blake and Ava Gardner (as a car hop, ZOWIE). It's more than likely that MGM, delighted with the rushes, was already planning a series for Heflin and Hunt, but their supersonic rising stars prevented the sequel possibilities (just like Walter Pidgeon's ascension stopped the studio's profitable Nick Carter franchise). This one's a keeper.

1947's **FALL GUY**, directed by the prolific Reginald LeBorg, is what kind critics refer to as "an odd duck." The potential here was enormous, but Poverty Row Monogram lacked the testicular equipment to propel this nevertheless engrossing programmer toward greater heights. The credits are impressive, the basis being a Cornell Woolrich story (the script by Jerry Warner and John O'Dea,

not so much). The Woolrich source-work was an infamous pulp, entitled *Cocaine*. This gives you an idea where the narrative was headed. The plot tells of an easily riled ex-GI who attends a coke party, and ends up wanted for the murder of a sultry blonde, stuffed in a closet. His best pal is a detective, who puts himself on the line trying to clear him. Since all the delirium (including snowballed partiers), wrong hallucinatory crime scene locales and ferocious mood swing behavior lend themselves to nose-candy enthusiasts, the Monogram refurbish leaves a less-than-desired effect upon viewers that often makes no sense. You see, while hyping the notorious title in the ads, the low-rent moguls saw fit to remove the drug from the scenario entirely, relying instead upon that old stand-by "givin' him a mickey."

There's still enough atmospheric, hazy paranoia to keep noir fans in check. Certainly the cast is quite enjoyable, save the lead. Clifford Penn (aka, Leo Penn, is better known as a future TV director; worse than any murder in this pic, he's also the procreator of Sean Penn, a crime for which there is no punishment heinous enough). Penn aside, there's Robert Armstrong as his detective buddy,

Rita Hayworth clone Teala Loring as a ga-ga possible *femme fatale*, the great Iris Adrian as a loudmouth, giggling reveler, plus Virginia Dale and Douglas Fowley to keep things moving. Since even a fall guy needs a fall guy, Elisha Cook, Jr., turns up with a bullseye practically embossed on his fedora.

FALL GUY was an early effort for producer Walter Mirisch, and it does look good (thanks to the work of cinematographer Mack Stengler, best known as the d.p. on *Leave it to Beaver*). For Woolrich fans (particularly of spine-tingling tales of the *Black Alibi* ilk), you'll probably figure out who the culprit actually is long before the knockout-dropped lead. We can only ponder what this nifty little nugget might have been in the hands of a Jacques Tourneur, Anthony Mann or Joseph H. Lewis. And with folks courageous enough to not tamper with a sniffer-to-snifter retread.

1954's **LOOPHOLE**, an Allied Artists special, has a lot going for it. The plot, concerning a spiral downward of a Hollywood bank teller falsely accused of grand larceny, offered many possibilities. The fact that an obsessed insurance

investigator is as eager to nail him as the greedy local nasties is a plus. The script by actor-turned-writer Warren Douglas has some but, frankly, not enough, pep to nevertheless make it a *noir* essential. Douglas is hampered with a by-the-numbers story concocted by Dwight V. Babcock and George Bricker (honest bank executives? Come now). But he *does* get a few quotable lines that define the teller's plight ("Sometimes there just doesn't seem to be an answer to anything." "What he needs is a taste of a rubber hose!").

While the negatives also include pedestrian direction by Harold Schuster (although I'd go as far to say that this might be Schuster's best work) and too much reliance on ripping off AA's own *The Phenix City Story* and TV's *Dragnet*, the pluses are major. The cast alone is representative of the *noir* gold standard, headed by Barry Sullivan (as the teller) and Charles MacGraw as the Raymond Burr/*Pitfall*-esque investigator. Right up there with 'em is Dorothy Malone, Mary Beth Hughes, Don Beddoe, Frank Sully and Carleton Young.

Add widescreen location photography (by William Sickner), a decent score by Paul Dunlap and *voila!*

– you have the recipe for a fun "poor bastard" way to spend 80 minutes.

BTW, **LOOPHOLE** is a socko title.

KID GLOVE KILLER. *Black and white. Full frame [1.37:1]; Mono audio. CAT # 1000547828.*

FALL GUY. *Black and white. Full frame [1.37:1]; Mono audio. CAT# 1000388516.*

LOOPHOLE. *Black and white. Widescreen [1.78:1; 16 x 9 anamorphic]; Mono audio. CAT# 1000388504.*

All titles available exclusively from the Warner Archive Collection: www.warnerarchive.com

HATE MALE

If ever a B-movie deserved an A-plus, it's 1944's **STRANGERS IN THE NIGHT**, a superb film noir obscurity by one of cinema's greatest directors, Anthony Mann. Up to now, this Republic Pictures gem was such a rarity that it often turned up on "lost films" lists. Hats off to Olive Films/Paramount Home Entertainment for its much-deserved resurrection, and on Blu-Ray (and DVD) no less!

For a B-picture – let alone a Republic B-picture – **STRANGERS IN THE NIGHT** tackles a hefty load of controversial psycho-sexual baggage. Above and beyond the prerequisite movie lust, there's gender inequality, unholy obsession and hints of incest and lesbianism. And all in under an hour (56 minutes, to be precise)!

The narrative essentially comprises a four-person cast – three of whom are scene-stealing pros; they are also all females. The one-sheet promotable obligatory last male standee (William Terry) is a cookie-cutter beefcake in a military uniform, and his role-reversal of the standard damsel-in-distress (appropriately a dumbbell-in-distress) is

yet another interesting aspect of this fascinating jaw-dropper.

There have been a handful of B-classics that have achieved masterpiece status, prominently Edger G. Ulmer's *Detour* (1945) and Joseph H. Lewis' *My Name is Julia Ross* (1946). Of course, they are worthy of these accolades – but, move over, boys – 'cause **STRANGERS IN THE NIGHT**, while not toppling their pantheon pecking order, certainly demands an equal share residence atop their roost.

Curiously enough, many of the visuals in **STRANGERS**, and indeed some of its themes of paranoia and entrapment, surfaced in *Julia Ross* (I more than suspect Lewis had seen this movie, a claim that I'm sure any astute viewer will attest to after a screening). Being a "B," it borrows shamelessly from other bigger pictures of the era, but remarkably ends up making them original. The primary sourcework (like all post-1940 romantic thrillers) is *Rebecca*, but there's also defiant nod to *Ladies in Retirement, Suspicion* (both 1941) and to a pair of concurrent 1944 blockbusters, *Laura* and *The Uninvited*. Why 1944

was the year of obsessed-with-beauteous-dead-femmes-in-paintings is beyond me. I imagine that **STRANGERS** reaped their harvest just in time for its autumn release – a budget-savvy example of genius marketing. And not impossible since the shooting schedule couldn't have lasted more than a couple of weeks – if *that* long.

STRANGERS IN THE NIGHT also moves like a V-2 rocket, and covers a number of international settings. It opens at the height of the then still-raging World War II. Somewhere in the South Pacific, a Marine sergeant sustains seemingly mortal wounds under fire. His convalescence in a field hospital is helped by maintaining a correspondence with a gorgeous American pen-pal. They begin a love affair in prose – so overpowering that he makes a (supposed) full recovery. He journeys to the woman's small-town coastal home – a magnificent mansion, overlooking foreboding cliffs and treacherous rip tides. Eyeing her spectacular portrait only gets his testosterone a-pumpin', but the lady is nowhere to be found. The cavernous manse is occupied only by the girl's carnivorous mother and her toadie servant, whose relationship is, even to the

thickest dullard, more than professional (and with a sadistic dash of B&D).

What goes on is a sick display of mind games, lies, torture and, eventually, murder – with the increasingly mentally unhinged ex-Marine reduced to a pitiful victim of the fierce napalm mom. The phobia-prone Sad Sack's only ally is the village's new doctor – an amazing no-nonsense performance by Virginia Grey (the one "star" name in the picture). Like Terry, Grey's character is an outsider – vocationally shunned by the town because of her sex. She nevertheless uses her abundant down time to help the soldier solve the mystery of his vanished dream lover.

The ultimate conclusion is a humdinger, to put it mildly – all resolved with a plethora of goose-bumping jumps and jolts (and, again, in under an hour). Of course, we must mention the creepy contributions of the dominant mistress and her subservient servant, a de Sade *tour de force*, delivered with aplomb by the genuinely scary Helene Thimig and poor Edith Barrett. As the villa's viper, Thimig is especially memorable, and seems to have channeled Gloria Holden from

Dracula's Daughter as her role model – with an ancillary MD (Mrs. Danvers) major in B-movie B-botchery from Judith Anderson University. Ditto for Barrett, her suffering tops anything in *12 Years a Slave*; indeed, her unique dark take on traditional movie twitch-and-hand-fluttering instantly makes her the mean-street queen of what can only be termed *zasupittsomnia*.

For me, the real star is director Mann, in the process of his climb to Hollywood movie-maker *extraordinaire*, but already in full command of the medium. Simply put, this is one of the finest B-pics EVER made, certainly the director's greatest work up until *T-Men* and *He Walked by Night*. I used to think *Desperate* and *Railroaded* showed embryonic signs of his talent; hell, I even admired (and still do) *Dr. Broadway* (high on my list of all-time title-grabbers). **STRANGERS IN THE NIGHT** not only takes the cake, but reduces the competition to mere crumbs in enviable The B-Noir Bake-off Finals.

The mix 'n' match screenplay by Bryant Ford and Paul Gangelin (from an original story by Philip MacDonald) contains a generous sprinkling of

chilling one-liners to admirably guide its audience along the relentless quicksilver twists and turns (what other picture gets yuks out of someone getting their hand caught in a mowing machine?). I can confidently predict that more than once, viewers will do verbal WTF double-takes of "Did they really say that?" and "What just happened here?"

The cinematography in **STRANGERS IN THE NIGHT** is terrific – as good as the best work from any A-picture from the Golden Age (or after). BIG kudos to the vastly underrated Reggie Lanning.

Suffice to say, **STRANGERS IN THE NIGHT** was a particularly marvelous discovery for me, since Anthony Mann is one of my favorite directors. It's always wonderful for a jaded seen-it-all idiot like me to find a picture by a cinematic hero that I had never experienced. I figured **STRANGERS IN THE NIGHT**'s anonymity was likely due to the fact that it wasn't that good and/or that the materials on it sucked. As occasionally is the case, I was heinously in the wrong in both departments. I've already given out with the hosannas regarding the former; now let me do the same for the latter. With the

exception of some minor negative wear and slight emulsion scratches, **STRANGERS IN THE NIGHT** hails from superb 35MM elements. The images are crystal-clear, the contrast *noir*-perfect. Damn, if only EVERY black-and-white picture looked like this, the world would indeed be a better place (well, at least for me). That and finding a primary doctor like Grey on my ACA plan.

STRANGERS IN THE NIGHT. Black and white. Full Frame [1.37:1; 1080p High Definition]. Mono audio [1.0 DTS-HD MA]. Olive Films/Paramount Home Entertainment. Cat #: OF552.

Also available on DVD: *Cat #: OF551.*

OLIVIA DEUX HAVILLAND

Today it's become a given cliché that any American movie containing words of more than four syllables shall be deemed "smart." I believe that this terminology goes back to the Siskel-Ebert days of the 1980s. Doesn't matter – because classic movie fans know the "real" smart movies, those which not only deliver the goods, but are brilliantly conceived and marketed. 1946's psychological noir **THE DARK MIRROR**, now on Blu-Ray and DVD from Olive Films/Paramount Home Entertainment, is a sterling example.

A Nunnally Johnson project in every sense of the word (he spearheaded, wrote the screenplay and produced the pic), **THE DARK MIRROR** opens with the brutal murder of a doctor. The prime suspect is the pretty woman operating the magazine/candy concession in the medical building lobby of the deceased sawbone's practice. But she has an airtight alibi.

The mystery isn't how she did it – or if she did it; we're totally convinced she's innocent until it's revealed that she's really twins, who often

playfully switch places. The befuddled investigating detective (Thomas Mitchell) is dumbfounded ("don't make anymore sense to me than Chinese music," he astutely hypothesizes); the romantically attracted psychologist (Lew Ayres), a "specialist" in twins (coincidentally a Playboy Channel subgenre) even more so. The sisters, who live together, dress alike and sexually compete, not only confound the authorities, but ratchet up the ever-present danger: one is kinda normal – the other a sadistic psychopath. Bummer! Do they get away with it? Can Dr. Ayres get the good sib to realize that she may be next? And which one really is the good one? "You can lose your mind," to quote the lyrics to *The Patty Duke Show* opening theme, a series which would warrant a close kinship, had it been supervised by Fritz Lang. Granted, in our present CSI/DNA-fueled society, this all may seem a bit ridiculous, but, in 1946, it was quite a conundrum.

Now here's where the "smart" stuff comes in. Johnson, who based his script on a story by writer Vladimir Pozner, was keen as to what was happening in the industry. In short, he hits all the right notes of this melancholic melody. The

opening resembles the previous year's *Mildred Pierce*; the Dimitri Tiomkin score apes the theremin of Rozsa's music to Hitchcock's *Spellbound* (also from 1945); since one sister ultimately attempts to drive the other insane, there are additional references to *Gaslight*; the direction is by Robert Siodmak, whose symbolic use of mirrors throughout, coupled with terrific noirish lighting (and excellent cinematography from Milton Krasner), underline his German expressionistic roots, fondly recalling earlier triumphs in the genre, *Phantom Lady, The Suspect* and even the *Double Indemnity*-plotted horror flick *Son of Dracula*. Of course, the smartest move of all was casting the spectacularly talented Olivia de Havilland to play both roles.

As Ruth and Terry (but not Ruth Terry), de Havilland is goose-flesh-raising astonishing. It's not just the old split screen "Why look, ain't special effects grand?" ploy, it's a thespian *tour de force* showcasing two completely different performances. The good sister is playfully deceitful while the evil version is a scheming harpy. It's really as if you're watching two actresses in action; upon close inspection, they

actually appear subtly physically different: innocent gullible de Havilland has a softer quality; mean kwazy de Havilland is tight-lipped with beady eyes. Not only should de Havilland been nominated and won for Best Actress (she actually did win that year for *To Each His Own*), she should have also been given Best Supporting Actress (with Best Animated Black and White Short Subject waiting in the wings). It certainly was her one-way ticket to the snake pit – which, only in Hollywood, could be considered a plus.

Another 1945 effort, the incredible B-movie *Bewitched* (the most atypical early 1940s flick ever to come out of MGM), starring the wonderful and underrated Phyllis Thaxter as a homicidal split personality, is likely to have also influenced Johnson; but, it's the imitation-is-the-highest-form-of-praise afterbirths that truly demand mention. The same year as **THE DARK MIRROR**, Warners released *A Stolen Life* starring Bette Davis as twins, but it was more of a traditional soap (the catalyst being Glenn Ford rather than dementia for its narrative meat); Davis would later retread these double set of footprints in the lurid 1964 thriller *Dead Ringer*, directed by her former

Now, Voyager co-star Paul Henreid. The connection to the 1950s *Three Faces of Eve* and its low-rent version *Lizzie* (both 1957) also are homage-worthy – although, as in *Bewitched*, these were studies of multiple personalities rather than genuine twin and triplet beings. Nevertheless comparisons to **THE DARK MIRROR** were made at the time – causing much buzz as to where the hell was the 1946 crazed fruit confection, which due to indy financing/distribution, had virtually disappeared from view.

THE DARK MIRROR was one of the first motion pictures made by International Pictures; earlier entries had been a pair of Gary Cooper comedies, *Along Came Jones* and *Casanova Brown* (also Johnson co-productions). International would last as a solo another couple of years (note the "two" variable in its history) before merging with Universal – thus morphing into Universal-International, which, again, doubly reinforces its meaning (wouldn't something universal be international?). The scant International titles were in limbo, finally hitting the TV airwaves in the 1960s. The prints, almost always 16MM, like evil de Havilland, showed signs of degeneration.

Murky, muddy with way-too-bass soundtracks, they weren't a pretty sight to behold – but were the only game in town. That's why I'm so ecstatic to see the Olive Films release of **THE DARK MIRROR**.

Some slight speckling aside (mostly relegated to reel changes), the movie, mercifully re-mastered, now glistens with 35MM detail (pushed immeasurably by the Blu-Ray edition) in silky, rich B&W shades and tones. It also provides the opportunity to appreciate d.p. Krasner's extraordinary work, as well as the mind-boggling special effects, which even in 2019, are jaw-dropping (a flawless shot in which one de Havilland leans on the shoulder of the other remains an epoch of matte-matching imagery). The mono sound, too, has been refurbished to the point where one can actually understand what the characters are talking about.

"Sisters can hate each other with such terrifying intensity," utters a denizen of **THE DARK MIRROR** – a quote which might be taken as gospel in discussing the real-life 70-year sibling rivalry between de Havilland and Joan Fontaine.

But leave us not harp on that; and instead rely upon the visually-defining paraphrase: "two can Livy as cheaply as one." Without hesitation, **THE DARK MIRROR** is highly recommended for film noir buffs; more importantly, it's a prerequisite for any Olivia de Havilland fan. In fact, doubly so.

THE DARK MIRROR: *Black and white; Full frame [1.37:1]; 1080p High Definition. Blu-Ray CAT # OF410.* SRP: $29.95.

Also available on DVD: CAT # OF409.

CHI SHYSTER BREW WITH AN AMBULANCE CHASER

An unlikely movie hero, unscrupulous Illinois mouthpiece John J. Malone, the demented brainchild of mystery author Craig Rice, remarkably made it to two big-screen comedic adventures, RKO's **Having Wonderful Crime** (1945) and MGM's **Mrs. O'Malley and Mr. Malone** (1950), now available in a delightful double-feature DVD-R (logically entitled the **JOHN J. MALONE MYSTERY DOUBLE FEATURE** from the Warner Archive Collection.

Malone, the human definition of Irish blarney, was always one step away from disbarment, due to his less-than-kosher methods of practicing his art. His addiction to lowlife dregs, gangsters, hookers, drunks, and other rogue's-gallery denizens endeared him to the underworld and the Fifth Estate, but caused countless untold headaches for the Chicago justice department and local police constabulary.

Fast-talking Malone was sorta like Nick Charles sans Nora and scruples. Where he rivaled the Thin Man sleuth was in charm and investigative skills.

True, the Saint, the Falcon, Boston Blackie and others often relied upon their underbelly connections to do the right thing. In Malone's case, the right thing is whatever and/or whoever fills his coffers with the most coin. While his competitors often weren't proud of the depths they had to slink to in order to come out on top, Malone simply doesn't care. In fact, when not cheating his ravishing secretary out of her pay, he's boasting of his infamous tactics, defiantly proud of his notoriety – not the least being the fact that he continually gets away with unbridled chicanery. Kinda like Congress.

Ironically, Malone would have been a perfect pre-Code Hollywood character (imagine an entire series of pics starring Cagney's *Jimmy the Gent*), yet while the watered-down 1940s and 1950s versions remain ingratiating on one level, they nevertheless were still distasteful enough to keep the majority of movie-goers away in droves.

Malone, aside from his lying, tampering with evidence, and penchant for violence, was also a womanizing fool. In both entries, Malone'll stop in mid-sentence to hit on some poor lass who unfortunately happened to choose a precise moment to cross his crooked path.

Hollywood Malone was lucky to have two likeable Irish mugs bring his antics to life: Pat O'Brien and James Whitmore. Also an amiable array of costars, writers, directors and cinematographers – no doubt proving that the devil is indeed in the details. The movies fortunately are jokey film-noirish adventures, never attempting to justify the activities of their protagonist. The plots themselves are silly and predictable – it's the riotous bumpy road from A to Z that fuels these rollicking vehicles. And, in keeping with the Warner Archive standards, both titles, culled from excellent 35mm materials, look and sound swell.

So sit back and relax, but keep your hands on your wallets and valuables: John J. Malone takes no prisoners.

In 1945's **Having Wonderful Crime** (a title parody of the famous Broadway play and later RKO movie *Having Wonderful Time*), Malone gets involved with sleazy mystics, murder and mayhem, beginning in a Chicago burlesque house and ending at a posh vacation spa (which proves for some to literally be a last resort). This provides a beautiful diverse springboard for the not-so-shy shyster's shenanigans through the various strata of 1940s urban society. The pacing is swift, thanks to the smooth direction by veteran comedy maven A. Edward Sutherland, working with an okay script that nevertheless took four cooks to concoct the narrative broth (Howard J. Green, Parke Levy, Craig Rice and Stewart Sterling). The cast is dynamite, with the supporting players saving the day for the leads. I mean, O'Brien is aces, but the inclusion of lowly young swinging couple/pals George Murphy and Carole Landis is a bit of a downer. They're obviously supposed to be in the mold of Topper's Kirbys ('ceptin' they're alive) with mold being the operative word. I mean, let's face it, even with a Lubitsch script (which this ain't) Murphy and Landis are no Cary Grant and Connie Bennett. Landis tries hard, and isn't too bad, but her cracks aren't all that wise. It's

Murphy, however, who's the lead anvil that sinks the picture whenever he opens his pie hole. He may have been a deft hoofer, but he's a lousy light comic. Murphy has the wacky delivery of Mitch McConnell, minus the madcap persona. O'Brien, on the other hand, can drift into the frame, toss off a "Good morning, how are ya?" with his patented Warner Bros. pre-Code staccato and effortlessly get a laff.

Again, it's the stellar support that saves the day with George Zucco and Lenore Aubert as mind-reading sham artists sharing top honors (Aubert being particularly adept at tossing out one-liners with panache). In close pursuit are such welcome pans as Gloria Holden, Wee Willie Davis, Chilli Williams, Rosemary LaPlanche, Emory Parnell and Dewey Robinson. From Sutherland's silent days are nice bits from Chester Conklin, Vernon Dent, Claire McDowell, Mildred Harris and Frank Mayo.

Considering the director's comic chops, it's a bit startling to see some rather graphic murders in the pic (unusual for both a 1940s movie, to say nothing of a comedy); this sprinkling of mean-street elements (as indicative of the period)

actually peps up **CRIME**, and, all-in-all, it's an entertaining, fun show. The photography by RKO house d.p. Frank Redman is quite good, as is the score by the studio's yeoman composer Leigh Harline.

It was a full five years before Malone tried his luck at crashing Hollywood again, and, in 1950, he hit pay dirt (and at MGM, no less) with the very unmarketable title of **MRS. O'MALLEY AND MR. MALONE**. The picture, mostly set on a Chicago-New York railroad, had the far more bankable moniker of "Once Upon a Train or The Loco-Motive" when it was a novel by Malone chronicler Stuart Palmer and the mouthpiece's creator Craig Rice. The script, by the prolific William Bowers (*Destry Rides Again*), has a fair share of verbal barbs, although the mystery isn't too mysterious. Indeed, even non-detective fans are likely to figure it out before the on-screen characters; however, as the travel ads used to state back in the day: Getting there is half the fun. In this case, it's all the fun.

Directed by comedy veteran Norman Taurog, the picture casts James Whitmore as the dishonorable

Malone; it's one of his best roles (and only starring one) from his Spencer Tracy, Jr., period. Mrs. O'Malley is the seemingly mismatched Marjorie Main. As with all pros, these two demonstrate their considerable thesp abilities quite well and bounce zingers off each other like recipients in a human racquetball match.

There was little risk on Metro's part, as this was B-movie in every aspect of the word. That (oft) said, a B-movie at MGM was an A-picture anywhere else. The look is extravagant, as are all the tech credits (Adolph Deutsche music, Ray June photography). The cast is superb, serving up the inhabitants of character-actor heaven, ca. 1950 (the "B" giveaway is the 69-minute running time).

Riding on and off the tracks are such notable *punims* as Fred Clark, Dorothy Malone, Douglas Fowley, Willard Waterman, Herb Vigran, Regis Toomey, Don Porter, Clinton Sundberg, James Burke, Frank Cady and Mae Clarke.

Whitmore's Malone is in full womanizing mode, balancing love stuff betwixt his gorgeous secretary (Phyllis Kirk), Main's even more

gorgeous niece (beauteous starlet Nancy Saunders) and the (most gorgeous of all) ex-wife of an embezzler (the amazing Ann Dvorak, who, mercifully, has much to do and, as far as I'm concerned, steals the show with her sassy demeanor).

Malone must track down a sleazy client who skipped town owing the shyster a fortune. Mrs. O'Malley is headed toward the Big Apple to likewise collect some swag, a 50K boodle won on a phone-in radio show (naturally, upon hearing this, Malone is interested in looking out for her welfare).

O'Malley's no fool and lets Malone play one, as she's a mystery buff and the fact that bodies seem to pile up around him is like catnip to the bored spinster.

Suffice to say, Marjorie's the main attraction in this movie. As a wise and strangely sophisticated boarding-house owner from Proudfoot, MT, her expertise at identifying an obscure ditty proves to be her dream come true. When her grubby miner tenants ask her if she's ready to leave Montana for

the bright lights of Manhattan, she snaps, "I've been ready to leave for thirty years!" *En route*, at a stopover in Chi, she even gets to warble a song, a horrific groaner entitled "Possum Up a Gum Stump" that is as lowbrow funny as it is agonizing.

I absolutely cherish one bit in **MRS. O'MALLEY AND MRS. MALONE**, and that's where the aforementioned just-released felon/client throws a lavish soiree for Malone and Chicago's upper crust of mobsters, entertainers and socialites – and ducks out before the party ends, sticking the swells with the tab. I personally find that admirable in that serves-ya-right karma sort of way.

There's also a concurrently shocking and hilarious moment where a gob-smacked Waterman believes that Whitmore and Main are having sex in a locked bathroom (I can vividly now envision thousands of readers simultaneously shrieking "Ewwww!").

That this melee of corpse and robbers is thoroughly enjoyed by the delighted female lead becomes underlined when she proudly unveils

evidence to the D.A.: "There it is, big as death!" It's funnier when you see it.

MGM, having turned down Martin & Lewis, was desperate to strike an economical comedic mother lode at the box-office. MGM had Main under-used and under contract for years before loaning her out to the lowly Universal-International for *The Egg and I*, a bonanza that mushroomed into the Ma and Pa Kettle franchise, earning the major-minor studio millions. This particularly pissed off Metro, who now was ferociously prowling the Writers Building for a chance to cash in on their previous missed opportunity. "MGM's New Scream Team!" blazed the uninspired ads (a head-butting two-shot, nearly identical to the posters for their 1949 hit *Adam's Rib*). Really? What was the old one? The one-sheets went one further, banging audiences over the noggin with "The uproarious star of 'Ma Kettle' comedies" and "The tobacco-chewing sergeant of 'Battleground' is a riot" How's that for a night-at-the-Movies incentive?

The idea that this combination could have survived more than one pairing is borderline

brazen, but, gotta admit, in keeping with its prime male character's tactics and ethics...it's *so* Malone!

JOHN J. MALONE MYSTERY DOUBLE FEATURE. *Black-and-white. Full frame [1.37:1]. Mono audio. Made-to-order DVD-R from the Warner Archive Collection. CAT # 1000547827.*

Available exclusively from The Warner Archive Collection: www.warnerarchive.com

BOGIE, BETTY, BLUE RIBBON BLU-RAYS

Not simply recommended, but MANDATORY editions to any classic movie collector's library are the quartet of terrific pics Humphrey Bogart and Lauren Bacall made for Warner Bros. between 1944-48. All are now available on extremely economical new Blu-Rays from the Warner Archive Collection.

Of course, this is an easy gig for me, as I don't have to acquaint anybody born within the last seventy years or so with these classics. They redefine celebrity star power, movie-making

expertise and genres (mostly, film noir); in short, veritable textbook patterns for Hollywood's Golden Age at its most garl'dernest goldenest.

In case you've been in Captain America coma land, the four in question are **TO HAVE AND HAVE NOT, THE BIG SLEEP, DARK PASSAGE** and **KEY LARGO**. Indeed, all have been readily available in decent DVD renditions for some time (even the old laserdiscs weren't too shabby). So why offer 'em up again? Blu-Ray! Truth be told, folks, there's no comparison. It's as if the four have just blown in on freshly lensed celluloid. The clarity, the detail, the contrast, the multi-leveled texture...all of that and more brings out the superb artistry of those in front of and behind the cameras. These 35MM transfers accentuate the thesps' histrionics, but also display first-rate cinematography, lighting, set and art direction, wardrobe and, natch, direction – each at the very essence of cinematic epoch. The crisp, clear audio ain't chopped liver, either.

But the know-it-all in me is pushing to say at least something on these must-have titles, so here goes!

Howard Hawks was truly an American star-maker. Well, perhaps personality-maker is more accurate. When one thinks of Gary Cooper, Cary Grant, Carole Lombard, Marilyn Monroe, John Wayne, Katharine (gag me) Hepburn, it's generally the way they act and react in a Hawks movie. This holds true for Humphrey Bogart, or, to be specific, Humphrey Bogart and Lauren Bacall. They became (and remain) an iconic (if not *the* iconic) Hollywood couple. And it's all due to Howard Hawks.

TO HAVE AND HAVE NOT began, according to the often Commander McBragg part of Hawks' "creative" revisionist brain, as part of a bet between the director and author Ernest Hemingway. "Give me your worst story, and I'll spin it into movie gold," Hawks told Hemingway. "That's easy," the writer replied. He tossed him **TO HAVE AND HAVE NOT**, sprinkled with his own critical expletives. Again, according to Hawks.

The movie was changed from an American fisherman on the California coast to an American soldier of fortune fisherman in a Vichy-controlled

French colony. Nineteen-year-old model-turned-actress Bacall, coached by Hawks' then wife Slim (a nickname Bacall's character is called in the movie), was unleashed on the Warner Bros. lot, and when her smoky eyes met Bogie's bloodshot lids, the fireworks went off. It's absolutely true that one can see the pair panting with genuine lust that evolves into everlasting love as the movie progresses. By wrap time, they were a not-so-secret item that the Warners publicity department thanked the Gods in heaven for. Coupled with some classic dialog (you know, that "whistle" line, etc.), courtesy of a rare script outing by William Faulkner (along with Hawks and von Sternberg favorite scribe Jules Furthman), plus a dynamite supporting cast (including Hawks favorite supporting actor Walter Brennan), and the pic had blockbuster written all over it.

Hawks, who was desperate to do a Southern gothic vampire horror movie (to be written by William Faulkner), was promised by Jack Warner to get the green light for *Dreadful Hollow* (the working title) if he delivered another Bogie-Bacall special. The director lassoed Faulkner, along with Leigh Brackett, to create one of the most

intoxicating, confusing and brilliant noirs ever made, the ultimate adaptation of Raymond Chandler's **THE BIG SLEEP**. With growing fascination about the star couple escalating even beyond the studio's dreams, the final cut proved a bit disappointing. Although it had already gone out to our troops in the South Pacific, Warners suits, including the pic's associate producer (J.L. himself) felt the movie lacked "...something." That something was more Bogie-Bacall mojo (this didn't stop our servicemen hooting and screaming in jubilant ecstasy whenever Bacall slinked upon the sheets stretched across jungle banyan trees). A year after the movie was completed, Warners put the title back in production, an unusual and expensive move that nevertheless reaped a goodly share of the 1946 box-office harvest. Key to the pic's unprecedented success was the addition of the now-legendary sexual horse-race byplay between the Marlowe and Vivian Rutledge (Bacall) characters.

Hawks never got to make his *Dreadful Hollow* movie, nor any further Bogart-Bacall outings. The former was due to the fact that Jack L. Warner was a bigger liar than Hawks, the latter essentially an

unpleasant incident at one of the director's parties. In front of Bacall (born Betty Joan Perske), Hawks made a crude anti-Semitic remark. Bogie stepped forward, but Betty stopped him. "Let's just leave." They did, and never had any contact with the director again.

TO HAVE AND HAVE NOT and **THE BIG SLEEP** represent the pinnacle of 1940s popcorn art. They are quintessential titles for the stars, the director, the genres and the history of Warner Bros. To reiterate, I have NEVER seen these two movies looking as fantastic as they do in these new Warners blu-rays. D.P. Sid Hickox has been rewarded after years – decades, really – of marginally acceptable (and frequently downright awful) prints. Added to this is the cache of extras on each disc. **TO HAVE AND HAVE NOT** contains a documentary on the two leads, the 1946 Technicolor Bob Clampett Merrie Melodies WB cartoon *Bacall to Arms*, a Lux Radio broadcast of the piece (with Bogie and Betty) and the trailer. **THE BIG SLEEP** takes supplements to another level, including BOTH versions of the movie, plus an exhaustively researched documentary, hosted by Robert Gitt, that examines the two editions of

the Hawks work that is fascinating to the nth degree.

1947's **DARK PASSAGE** is the sick child of the quartet. By that I mean it was the least successful at the box office, and the movie that (at the time) bore the brunt of a critical backlash. I've always loved it. Today, it's considered a noir masterpiece, and rightly so. It also proved to be the cornerstone of the Delmer Daves following, most deservedly due to the innovative, on-location visual storytelling. The plot, which writer/director Daves derived from a fantastic David Goodis novel, concerns a wrongly accused wife-murderer who escapes from San Quentin and hooks up with a variety of mysterious (and lethal) dames before hitting upon the answers that could likely solve the case and vindicate him. His coincidentally-on-purpose connecting with a sultry artist (and shacking up in her abode) blossoms into true lust/love, but not before he must make some difficult decisions – like using plastic surgery to change his appearance. Only in film noir can a guy on the run meet a cab driver who knows a defrocked doc who performs illegal operations at three in the morning. It's moments

like these that give me hope for our troubled world.

The accused, one Vincent Parry, is, of course, Bogie, and Irene Jansen, the amorous babe, be Bacall. The neat device of having the camera play POV Parry for the first half of the movie (where Bogart supposedly looks like character actor Frank Wilcox, shown in a newspaper photo from his trial) is what soured Jack Warner on **DARK PASSAGE**. He claimed not showing Bogart (although we hear him) for such a long duration is what killed the movie's potential box-office take. The weird fact is that the identical procedure was done the same year at MGM and by star-director Robert Montgomery for his Phillip Marlowe noir *Lady in the Lake* (it wasn't a big draw during its initial release either).

But **DARK PASSAGE** holds up way better than *Lake*, and is thoroughly thrilling from fade-in to fade-out. It also boasts a magnificent supporting cast, including Agnes Moorehead, in possibly her greatest screen role. Others of note are Bruce Bennett, Tom D'Andrea (as that cabbie), House Peters (as the unlicensed plastic surgeon) and, my

favorite, comic Clifton Young as one of noir's sleaziest and detestable individuals (think of a satanic hybrid of Richard Widmark and Troy Donahue). Young was the comedian/actor best-known for his multiple turns in the popular Warners Joe McDoakes shorts, starring George O'Hanlon. Sadly, he never really followed up his ace portrayal here, and, even more depressingly, died at age 33, rumored to be a suicide.

DARK PASSAGE has it all: dames, tough guys, violence, sinister surgeons, wiseguy hacks and even a jazz-music subplot – all beautifully wrapped up in a mean-streets black-and-white celluloid package by the ubiquitous Hickox (the music by Franz Waxman is another plus). After **THE BIG SLEEP**, this is often the Bogart-Bacall title most requested by fans (especially those who lean toward noir). In short, time has aged this vintage flick quite well, joining the throngs of debut flop classics, *Vertigo, Marnie, Sweet Smell of Success, Citizen Kane, The Magnificent Ambersons, Ace in the Hole, The Red Badge of Courage* and others. The Blu-Ray looks and sounds fantastic, and is appended by some neat extras, including the documentary *Hold Your*

Breath and Cross Your Fingers and the sensational "all-star" 1947 Technicolor Warners Friz Freleng Merrie Melodies Bugs Bunny cartoon *Slick Hare* (featuring Bogie & Baby).

1948's **KEY LARGO** has always been the most problematic Bogart-Bacall title for me. And that rested solely on the eons of lousy prints I suffered through during what are laughingly called my formative years. Agreed, this is firmly relegated to the murky, gray 16MM copies that were screened throughout the 1960s and early 1970s on WNEW-TV, here in New York. To put it mildly, the negligible visuals were a turnoff. Trust me, as much as a spectacular print can elevate a mediocre movie, a bad print can ruin a great one. **KEY LARGO** is a great one.

The screenplay, based on Maxwell Anderson's 1939 play, and updated to post-WWII America by director John Huston and Richard Brooks, is a tense, hellish swan dive into film noir. A disturbed ex-Army officer, Frank McCleod (Bogart), visits the title locale, residence of a hotel, owned by the father and widow of his deceased friend who served under his command. It's off-season, and

the fishing resort is populated by a gaggle of big city lowlifes, who ostensibly are there to monopolize the wide open deep sea opportunities. Ain't so.

The group of aliases comprise a ferocious mob, led by an illegally returned deportee, Johnny Rocco (Edward G. Robinson, in, possibly his most loathsome role – one that makes *Little Caesar* look like a Hugh Herbert gag reel).

The conflicts and body language that during my adolescence I viewed as "too talky" are, in actuality, lip-biting riveting. The interplay between the stellar cast is extraordinary; undeniably, **LARGO** easily contains the finest roster of board-trodders in *any* Bogart-Bacall outing. Aside from the three already mentioned, there's a non-over-the-top Lionel Barrymore, Tomas Gomez, Marc Lawrence, Dan Seymour, John Rodney, Monte Blue, John Litel, Jay Silverheels, and, best of all, Claire Trevor, in her Oscar-winning performance as a one-time primo torch singer reduced to an alcoholic wretch by Robinson's character. Indeed, we learn that Rocco is not only a vicious mob ruler, but a pathological liar, racist, sexual predator (the moment when he

merrily whispers a personal request into Bacall's ear is particularly stomach-turning), and, maybe even a traitor. The snarky possibility discussed during the proceedings ("Let him be President") is thus contemporarily cringe worthy.

The inevitable showdown aboard a fog-bound boat headed toward Cuba is as suspenseful a vignette of revenge as ever captured on perforated film (it's interesting to think of the two male adversaries in *Bullets or Ballots*, filmed twelve years earlier, where the good guy/bad guy roles were switched). I have never more enjoyed a cinematic instance of the tables being turned. Nevertheless there's a sick moment where Bogart seems to relish the sadism he now issues as payback: one shot, one expression, Bogart and Huston at their best.

The mindset in McCleod's head seems to muster up the courage to romantically pursue his friend's widow and to reside in the remote rural spot he can comfortably call home, "home being Key Largo" as he earlier intones. As with all noir and most Huston pics, there are no guarantees. To find out if he makes it, you'll have to take a

chance on this exquisite Blu-Ray. The gorgeous contrast, 1080p crystal clarity and the pristine 35mm quality makes watching this platter (especially if one is lucky enough to do so on a big screen) replicate seeing this picture during the first week of its 1948 debut. The Blu-Ray does monumental justice to Karl Freund's blistering black-and-white photography; the audio does likewise to Max Steiner's excellent churning music. Ditto, the superb special effects by Robert Burks and William McGann and the haunting, eerily beautiful Florida location work. It's a perfect finale to the Bogart-Bacall quadrumvirate.

For Warner Bros., the ocean-engulfed **KEY LARGO** represented a literal high-water mark for the studio. Bogart and Huston became Jack Warner's heroes. Aside from **LARGO**, 1948 also produced *Treasure of the Sierra Madre*. It was the best year Warners had in a long time. The usually stingy with praise J.L. admittedly doled out kudos to the actor and director for just short of saving the company.

All movies are black-and-white, full frame [1.37:1; 1080p High Definiton] with 2.0 DTS-HD MA. SRP: @$21.99.

TO HAVE AND HAVE NOT *[CAT # 1000600530]*
THE BIG SLEEP *[CAT# 1000595077]*
DARK PASSAGE *[CAT# 1000574975]*
KEY LARGO *[CAT# 1000595079]*

Available from the Warner Archive Collection: www.wbshop.com/warnerarchive or online retailers where DVDs and Blu-rays® are sold.

\

SCUM KIND OF WONDERFUL

One of those WTF Hollywood rarities – a Yuletide movie frothing with film noir elements – 1947's **CHRISTMAS EVE** finally comes to Blu-Ray, thanks to the malevolent elves at Olive Films and Paramount Home Entertainment.

Imagine Frank Capra directing a Raymond Chandler or Cornell Woolrich holiday tale and you have a pretty good idea of what you're in for. Matilda Reid (aka Aunt Matilda, aka Ann Harding) was one of the great beauties of 1890s New York. Her looks paled next to her smarts and she amassed millions in investments. The investments, however, paled next to her eccentricities, which include a dinner table surrounded by electric trains to shuttle condiments to her guests, and shoveling bird seed on her floor each morning before opening the doors and French windows to let Manhattan fowl feast in style. But there's also Manhattan foul, particularly her sleazy, oily relative Phillip Hastings (Reginald Denny), who, armed with a judge (Clarence Kolb) and shrink (Carl Harbord), is

determined to commit the now-aged woman to an insane asylum and reap her fortune.

But Matty has an ace card, or so she thinks. Decades earlier, she adopted three infant orphans and raised them as her sons. The lady has high hopes that these grownup versions will come to her aid. Alas, it looks like the ace card is a joker. In triplicate. The lads are bad boys. And there is the rub.

Michael Brooks, an over-the-hill playboy/fake entrepreneur (with enough bags under his eyes to open a Samsonite outlet), is plotting to marry into dough to alleviate 75K in bad checks. Ann Nelson, his snarky ex (and still occasional squeeze), whom he passes off as his sister, has other ideas. That this pair is enacted by George Brent and Joan Blondell ignites a cinematic spark that recalls the best of their pre-Code Warners days. Can the pair's verbal battles and schemes to bilk the 400 bend to the do-the-right-thing sector? They might, due to Michael's learning of his mom's plight. Well, maybe.

Son # 2, Mario Torio (George Raft) has escaped a criminal rap in the States, and now resides in South America, where he runs a high-roller casino/nightclub. His main source of romance is Jean (Dolores Moran, coincidentally, wife of the pic's producer Benedict Bogeaus), who, unbeknownst to Torio, is the puppet of an ex-Nazi (Konstantin Shayne), now a war criminal hiding out below the border after taking a powder prior to the Nuremburg trials.

Son # 3, Johnny (Randolph Scott, in his last non-oater before enforcing his "westerns only" policy) is an alcoholic, womanizing rodeo rider, down on his luck, who, upon hearing of Matilda's problems, figures it's a good way to maybe score some moolah. He returns to New York, and immediately hooks up with a *femme fatale* (Virginia Field) involved in a loathsome baby racketeering crime ring.

It's *that* kind of a holiday movie. True, any Christmas pic featuring Nazis and a subplot where one of the beauteous heroines gets murdered is tops in my book. And, certainly, in this area, **CHRISTMAS EVE** doesn't disappoint. The cast, as

assembled by aforementioned indie producer Borgeaus (who released this poison bon-bon through UA), is phenomenal. Aside from the excellent Harding as old Matilda (in actuality, younger than both Raft and Scott, and only two years older than Brent), and the other already listed cast members, the stellar thesps include Douglass Dumbrille, Dennis Hoey, Joe Sawyer, Molly Lamont, John Litel, Walter Sande, Andrew Tombes, Marie (Blossom Rock) Blake, J. Farrell MacDonald and John Indrisano. The script, too, can't be faulted. It's a honey, as constructed by Laurence Stallings (*What Price Glory?*, *The Big Parade*, *She Wore a Yellow Ribbon*, *Three Godfathers*), who wrote the story, and contributed to the screenplay with Richard H. Landau plus uncredited participation from Arch Oboler and, in one of his first movie gigs, Robert Altman (all obviously saw the previous year's *Gilda* and *Notorious*).

The shimmering monochrome photography is by Gordon Avil. Sadly, this is where the Olive/Paramount Blu-Ray drops the Christmas ball. Although it's not really their fault. While utilizing the best elements available to create this

transfer, the results are less than perfect. Seventy-two years of neglect have taken their toll; while certainly viewable, and with nice contrast, images appear occasionally soft and washed-out. That said, we should be grateful for what we have. It is that time of the year after all. The audio, a bit on the bass side and slightly low, nevertheless does deliver and allows us to savor the score by Heinz Roemheld and much of the snappy noirish dialog ("Raise your hands to the perpendicular," demands Scott, brandishing a gat).

The biggest letdown is the choice of directors. Edwin L. Marin was a total professional, and his work here is serviceable. Yet, one can only imagine what the results might have been in the hands of a Jacques Tourneur, Don Siegel, Anthony Mann or Joseph H. Lewis. Again, the script and cast are so good they help immensely to smooth over any directorial shortcomings.

Long story short, for those who like their mean streets adorned with mistletoe and bullets, **CHRISTMAS EVE** is the Blu-Ray gift that keeps on giving.

CHRISTMAS EVE. *Black and white. Full frame [1.33:1]; 1080p High Definition. 1.0 DTS-HD MA. Olive Films/Paramount Home Entertainment. CAT# OF1155.*

CAIN ENABLED

Especially timely these days, Abraham Polonsky's vicious modern 1948 biblical parable (by route of film noir) **FORCE OF EVIL** comes to Blu-Ray in a dynamite edition, courtesy of Olive Films/Paramount Home Entertainment.

The pic, starring and coproduced by John Garfield, was the actor's and writer/director's eagerly anticipated follow-up to their 1947 smash *Body and Soul* (Polonsky scripted that Robert Rossen iconic boxing saga). The movie, adapted from Ira Wolfert's novel *Tucker's People*, was made independently via Garfield's cofounded company, Enterprise Studios, a short-lived concern that nevertheless defined the power of the little fish in the big cinematic pond; almost every title Enterprise produced is a major addition to any classic collector's library. The success of the

aforementioned *Body and Soul* guaranteed A+ distribution for Enterprise, bizarrely via the unlikely gooey dream factory known as MGM.

Succinctly put, **FORCE OF EVIL** is one of the best movies of the 1940s, and one of the greatest noirs ever made. The dialog, the violence, the angst, the entire look and feel of the production is chillingly spine-tingling and exciting. It remains one of my two favorite John Garfield movies (the other being 1950's *The Breaking Point*).

The story, set in Manhattan (and filmed there, almost simultaneously with Metro's *On the Town*), concerns two streetwise brothers, Joe and Leo Morse (Garfield and Thomas Gomez). Leo, the older sib, also serves as Joe's surrogate father. Like Joe, Leo is smart, savvy and was probably, at one point, destined to go far. But his love for his even smarter bro put a dent into the good intentions machine. Leo ends up in the old hood *as* an old hood, running an illegal penny-ante bank loan/numbers service. The positive spin is that Leo treats his employees (all hard-luck locals and otherwise unemployable) and clients with decency and care. He looks after everyone, rarely

bothering to bother about himself (he has a terminal cardiac problem); his main concern was for a long time his brother, making sure there are enough funds to send him through college and law school, thereby allowing the would-be attorney to amount to something. That's where irony throws a monkey wrench into the works. Joe DOES become a success, but as a mob mouthpiece, preying on the poor while bolstering his rep as a go-between for the mob and crooked politicians. You want access to a top politico, you go through Joe. By his own definition, his legal skills are appended by his slithery charm as a "fixer." Are the goose-bumps rising on the back of your neck yet? Stay tuned.

Trouble is, the mobsters aren't happy with the majority of the East Coast rackets; they want it all. So fixer Joe's latest assignment is to muscle in on his own brother. As is the case in noir, there's NO WAY this is going to work out well. And it doesn't. Decades ahead of its time via tough dialog and jaw-dropping graphic violence, **FORCE OF EVIL** delivers the goods in a way few movies have. Its influence has inspired everyone from Martin Scorsese (who does a special introduction

on the disc) to Quentin Tarantino to Don Siegel, Phil Karlson, and, notably Robert Aldrich (who was assistant director on the picture).

The performances are magnificent, ranging from Garfield (when was he ever NOT terrific?), newcomer Beatrice Pearson (as a lovely new nabe-babe employee of Leo's, whose intelligence and virtue bugs Joe), Roy Roberts, Paul Fix, Howard Chamberlain, Murray Alper, William Challee, Cliff Clark, Arthur O'Connell, Paul Frees, Paul Newlan and Jack Lambert. It's Thomas Gomez, however, who nearly steals the show as brother Leo (one of his rare, and possibly only, sympathetic screen roles); long story short, he's Oscar-worthy outstanding (he wasn't even nominated; FYI, it would have been a tough choice, the Best Supporting Actor that year went to Walter Huston in *Treasure of the Sierra Madre*).

The direction and writing by Polonsky is textbook perfect. It's easily his best movie, the trenchant lines sticking in one's craw long after the final fade-out. For example, enjoying his role as fixer, Joe calms his suspicious employers with, "You look out for the politics, I'll take care of the

business." There's the constant lying (say it enough times, and the fools'll buy it): "A man can spend the rest of his life trying to remember what he should have said...Life's a bank, except you can't get the money out." Called out by his far more righteous brother, Joe shrugs, "Wall Street's gonna make me one million dollars...Rich relatives are better than medicine." To which Leo responds, "Come around when I'm dead." Beatrice's genuine growing feelings for Joe questions his ethics and morals. Won't he be afraid of being thrown under that bus? "Lawyers aren't protected by the law...If you don't get killed, it's a lucky day..."

Appending the above is the dazzling black-and-white NYC location photography by George Barnes, and the score by David Raksin. Obviously, this is a New York movie from frame one and, along with *Sweet Smell of Success* and *Taxi Driver*, paints the city as the twentieth-century portal to hell. The last act sequences of Garfield stumbling across the concrete landscapes at dawn are tantamount to a never-ending nightmare.

The movie, unlike *Body and Soul*, didn't fare as well with audiences, although, critically, it was acclaimed by the reviewers astute enough to recognize its brilliance (not surprisingly, in post-war Europe, it became an instant fave).

The politics on display in front of and behind-the-scenes no doubt played a big part in **FORCE OF EVIL**'s short legs with 1948 America. Both Polonsky and Garfield would soon become victims of McCarthyism and be blacklisted with fatal consequences (Garfield died of a heart attack in 1951; Polonsky wouldn't officially work again until 1968). **FORCE OF EVIL** was falsely cited as evidence in the HUAC investigations as to the filmmakers' subversive anti-Americanism.

Naturally, Louis B. Mayer hated the picture, as he did with virtually every Enterprise/Metro release. He likened them to sewage that needed to be flushed down the toilet. Fortunately, his days at MGM were numbered, and the new incoming progressive liberal crew was able to veto most of his decisions (he also despised such mammoth hits as *The Hucksters, Battleground, The Asphalt Jungle, Intruder in the Dust* and others). Mayer's

holding fast to the old MGM family values resulted in the infamous mega-Technicolor flop *Summer Holiday*. Yet, he claimed the incoming Dore Schary contingent had no clue how to make a musical, the type of picture MGM was known for. Once Mayer was completely out, the Schary regime produced *An American in Paris, Singin' in the Rain* and *The Band Wagon*.

Because of the blacklist, **FORCE OF EVIL** became a fairly difficult to see masterpiece. With Paramount obtaining the rights to the entire Enterprise output, this heinous celluloid obstruction became less of an obstacle. Acceptable laserdiscs and DVDs were made available in the past, but they can in no way compare to the stunning quality of this 1080p High Definition transfer (it's even enclosed in a slipcover featuring the original one-sheet – a *piece de resistance* of hyperbole; "John Garfield Puts his Body and Soul into **FORCE OF EVIL**," it heralds).

In closing, **FORCE OF EVIL** is a must-have for every 1940s collection/film noir library. It is one of those movies that just gets better with every

screening. And no one ever purred "perverse" more beautifully (or even poetically) than John Garfield.

FORCE OF EVIL. *Black and White. Full frame [1.33.:1; 1080p High Definition]; 2.0 DTS-HD MA. Olive Films/Paramount Home Entertainment. CAT # OF454.*

SOMETHING STANWYCK-ED THIS WAY COMES...

The recent Olive Film/Paramount Home Video release of the 1950 thriller **NO MAN OF HER OWN** defines what classic movie collecting is all about. A film noir angst-fest starring arguably the unchallenged queen of the genre, Barbara Stanwyck (an actress with at least 14 solid noirs under her belt – plus an additional quarter dozen fringe-related offerings in the wings), this unsettling Mitchell Leisen-directed nail-biter racks up big points if only for the fact that nobody's ever heard of it. One wonders how this is possible. Noir is, after all, one of home vid's hottest genres. The studio is big, the cast is big, the director is big...Even the source work derives

from the mind of one of noir's crown princes, Cornell Woolrich (here billed under his pseudonym, William Irish). It just might be the unsavory plotline – which was likely considered way too distasteful for 1950 audiences, but now only contributes to this cinematic obscurity's wow factor.

There's so much to talk about – the brief Tod Browning opening framing story, the first "real" sequence depicting unwed mother Stanwyck intruding upon the domicile of lethal penetrator Lyle Bettger (interrupting a session with his new girl friend, Carole Mattews: "Don't ever try and brush me off like that!" she tells him after he unceremoniously tosses Babs out, discreetly giving her a cross-country rail ticket and a whopping five dollar bill for expenses).

Before getting down to the extremely nasty nitty gritty, leave us discuss the principals of this Hollywood penny dreadful.

As far as Barbara Stanwyck goes, there's really nothing left to say. From her early turns in Warners pre-Code dramas like *Baby Face* to her

Oscar-nominated role in 1937's *Stella Dallas*, Stany's the berries. Terrific in drama, amazing in comedies – there was nothing this multi-talented actress couldn't do...Then came Billy Wilder and *Double Indemnity* – and yet another Stanwyck emerged (and another of her four Oscar nominations), the evil *femme fatale*. *The Strange Love of Martha Ivers* cemented the dragon lady image for which another Oscar nod in 1948's *Sorry, Wrong Number* seemed like a just dessert (for those counting, the fourth nomination was for 1941's *Ball of Fire*). For durability alone, **NO MAN OF HER OWN**, which would be followed by Anthony Mann's noirish western *The Furies* and preceded Robert Siodmak's *The File on Thelma Jordon* earned her a monument in mean street immortality. Specializing in types that cried out for viewers to despise her, Stanwyck nevertheless delighted audiences with her lowly portrayals well into her successful foray into television. In her mid-seventies, she was making believable GILF advances to priest Richard Chamberlain in *The Thorn Birds* – proving that you can't keep a bad girl down (perhaps an ill-chosen cliché since that was generally a position her characters lasciviously enjoyed).

John Lund, Stanwyck's co-star in **NO MAN OF HER OWN**, is a bravura example of where the declining studio system went wrong. First seen in Paramount's 1946 *To Each His Own* (playing the dual role of Olivia de Havilland's lover and bastard son), Lund was enthusiastically signed by the studio to a long-term contract, where he was shamefully misused before being dropped like a hot potato in the early 1950s. Constantly thrown into bland leading man parts opposite such subtle co-stars as Betty Hutton, Lund, not surprisingly, always looked uncomfortable, exhibiting a variety of pained facial expressions that indicated that he shouldn't have eaten that last burrito. Again, Billy Wilder mined some gold – pitting him in the center of a triangle balanced by Jean Arthur and Marlene Dietrich in 1948's *A Foreign Affair*. For a change, Lund wasn't in an embarrassed ill-suited cringe situation that in real life demanded Preparation H. He was genuinely funny as the less-than-honorable officer in postwar Berlin. One would think that Paramount would have taken the baton and kept him out of pictures whose void could have been filled by a cardboard standee. Only rarely was Lund given a chance to demonstrate his considerable comic finesse,

notably as Al – Marie Wilson's sleazy opportunistic boyfriend – in the two *My Friend Irma* pics and in the horribly neglected Richard Haydn-directed 1948 screwball farce *Miss Tatlock's Millions*. The same year he played the tricycle fourth wheel in *High Society* (the MGM musical remake of *The Philadelphia Story*, and, sadly, not the Bowery Boys names-the-same '56 entry), he appeared in an early cheapie Roger Corman western *Five Guns West*. The latter was a near death knell career project, and the wincing frowning Lund more than ever resembled a poster child for Crohn's Disease.

Creepy Lyle Bettger was the perfect oily villain of the early 1950s. His array of movie scumbags in a handful of Paramount titles forever relegated him to Slimeball Heaven. Bettger perennially seemed to be wearing a fancy showoff vest even when in bathing trunks. His Cheshire cat grin revealed at least eighteen rows of sharpened teeth which fans knew were in varying shades of yellow (an amazing feat, as most of Bettger's prime work was in black and white). His presence was such that one can practically smell the scent of mold and decay whenever he enters the frame. Like fellow

screen lunatic Raymond Burr, Bettger eventually found vindication in the arms of Erle Stanley Gardner. Just like *Perry Mason* humanized Burr, Gardner's 1957 TV series *The Court of Last Resort* gave us a kinder gentler Bettger. But he (or the show) never caught on like Burr's – no doubt due to the expense of vast amounts of air freshener that necessitated the weekly experience of having him invade viewers' living rooms.

Director Mitchell Leisen is the most bizarre puzzle piece of **NO MAN OF HER OWN**. Renowned as a master of (mostly) romantic comedy, Leisen began working for Cecil B. DeMille, often as a set and costume designer. While he guided numerous stars (primarily actresses) triumphantly through their paces – scoring an Academy Award for de Havilland in the earlier discussed *To Each His Own* and a deserved Best Supporting Actress nomination for Thelma Ritter in *The Mating Season*, Leisen, or more precisely, his style hasn't aged well. His filmic ambling on such key works as *Death Takes a Holiday*, *Murder at the Vanities*, *Hands Across the Table* and *Take a Letter, Darling* is about as light and airy as *Mourning Becomes Electra*. Even his "masterpieces," 1937's *Easy*

Living and 1939's *Midnight*, as fun as they still are, tend to have more drag moments than a Greenwich Village Cher party.

It should be noted that Preston Sturges and the ubiquitous Billy Wilder both credit Leisen for their aspiring to become directors. We should also mention that this is a back-handed compliment. The reason behind their decisions was wholly due to their disapproval of the way he "...destroyed" their scripts (Wilder co-wrote *Midnight, Arise, My Love* and *Hold Back the Dawn*; Sturges penned *Easy Living* and *Remember the Night*). Insult to injury, Leisen's Technicolor take on Moss Hart's *Lady in the Dark* is generally considered one of the worst movies made during Hollywood's Golden Era. **NO MAN OF HER OWN** was an atypical project and nearly as crazed as one of my guilty pleasures, Leisen's 1949 *Bride of Vengeance* which presented Paulette Goddard as Lucretia Borgia, another agonizing Lund performance and a ya-gotta-see-it-ta-believe-it eye-popping ham feast by Macdonald Carey as Goddard's bro, Cesare. Leisen hung on though – moving into television and directing well into the 1960s on

such iconic fare as *The Twilight Zone* and *The Girl From U.N.C.L.E.*

NO MAN OF HER OWN (which bears no relation to a 1932 Paramount drama starring Gable and Lombard in their only movie together; it was more appropriately christened *The Lie* overseas) begins with a *Rebecca*-esque narration by Stanwyck. Cut to the actress sitting in an affluent drawing room with supposed husband Lund, already displaying signs of gastritis. Stanwyck, too, exhibits symptoms of excruciating torture. This is at once explained by a pull-back revealing her illegitimate newborn resting in her lap. What makes this fade-in so shocking isn't the baby's birth history, but the sprout itself. I've got to say it: this infant's got the biggest head I've ever seen. "Oh, my God!" screamed my wife at the sight of this human Mardi Gras float (FYI she also inquired as to the what that smell was when Bettger made his initial entrance). It's truly as if Stanwyck had given birth to a fully-grown John Merrick; this skin-crawling moment dominated everything else that unspooled as the movie went on – quite an admission since the narrative is beyond drug-induced.

Remember we mentioned the train ticket? Well here's what happens next. Stanwyck makes the acquaintance of newlyweds Richard Denning and Phyllis Thaxter (a thankless bit from an underrated actress I love; think I'm kidding? Check out her work on episodes of *Alfred Hitchcock Presents*). They're traveling to visit Denning's Romney-rich parents, who've never met Thaxter (a whirlwind courtship that kept them away for months; now Thaxter's pregnant, but, unlike Stanwyck, hers is legit).

As all women apparently do (especially those who were strangers up until moments before), they retire to the ladies room and exchange jewelry (well Thaxter does, Stanwyck has none – having even lost that generous five-spot Bettger threw in for good measure). On cue, the train derails, killing all on-board (including unbilled porter Dooley Wilson), save Stanwyck and Giant Baby Head who arrives prematurely and whose weight may have been the cause of the accident. I'd like to add that this action sequence is similar to the train wreck caused by....*Lyle Bettger* in DeMille's *The Greatest Show on Earth* two years later. Trvia

trauma: keep Bettger away from trains and Michael Rennie out of elevators!

Now Stanwyck is faced with a dilemma: eke out a broke but honest existence, or, scam Denning's folks and live in luxury (she's still got that identifying ring). True this is just a variation of TV's *Wife Swap*, except here it's a deception that soon leads to blackmail and murder. Scenes of Stanwyck receiving unsigned blackmail notes are pure Woolrich and recall Jimmy Stewart's poison pen letters to Raymond Burr in *Rear Window*. The primo acting *tour de force* comes when Stanwyck decides to turn from victim to murderess; it's all done in one long take, no dialogue...a simple medium close-up. It's hands-down the best scene in the movie. I'd have given her an Oscar just for that shot – well, that and lugging her Pinky and the Brain spawn across the frame. Lund, who is Denning's brother, further compounds Stanwyck's problems; she's lusting for her dead spouse's sib...even though she never actually was..., but he doesn't know that...although morally and ethically...oh HELL, it worked for Peter Bogdanovich!

The supporting cast of **NO MAN OF HER OWN** is chock full of "Oh, yeah, him/her" types. There's a decidedly old school feel to this movie – sort of a pre-Code throwback. Henry O'Neill, Jane Cowl and Esther Dale essentially enact the same parts they had been playing for over a quarter of a century.

The DVD is from pristine 35MM elements and showcase the dark gloomy, monochrome photography of <u>Daniel Fapp</u> to great advantage. The audio is crisp and offers a nice Hugo Friedhofer score.

If you're looking for something virtually unknown to spring upon unsuspecting guests, you really can't do better than **NO MAN OF HER OWN**. Never has loathsomeness been more entertaining...and that's without the cumbrous cranium!

NO MAN OF HER OWN. *Black and White; Full Frame [1.33:1]; dual layer.*
Olive Films/Paramount Home Entertainment. CAT # OF369.

CATCH OF THE DAY

I'm always delighted to be able to finally see an elusive motion picture I've heard about most of my adult life; if it's a film noir, so much the better. Thus, win/win with the recent Blu-Ray release of the 1950 obscurity **TRY AND GET ME**, now available through Olive Films/Paramount Home Entertainment.

Made independently on a low budget for Robert Stillman Productions, with a guaranteed distribution deal from United Artists, **TRY AND GET ME** is one of those spidery web of hopelessness dramas so far-fetched that it *must* be based on a true story. And so it is.

The movie revolves around the infamous 1933 Brooke Hart kidnapping/murder case and subsequent horrific vigilante justice, which inspired the 1936 Fritz Lang classic *Fury*. In fact, the pic, either as an in-joke or homage, was originally entitled *The Sound of Fury* (I prefer to think it was the former).

Unlike the earlier version, the protagonist is not a totally innocent dupe, but rather (as in the actual case) a pair of thieves looking to up their game. One, Jerry Slocum (Lloyd Bridges at his sleaziest) is a career criminal, the other, Howard Tyler (the always underrated Frank Lovejoy), a poor schnook who couldn't get a break if a truckload of crutches fell on him.

Tyler, barely getting by, is nevertheless unswervingly championed by his loyal, longing (and needy) wife (Kathleen Ryan) and child (the unfortunately named Donald Smelick). Desperate to work, Tyler travels hours each day trying to pick up any kind of employment. Disillusioned, he enters a bowling alley for some relief and a brewski. And, wham, there it happens. It's the old, "A fool walks into a bar (well, bowling alley)..." wheeze. Lovejoy gravitates toward loudmouth cool dude Bridges, a self-made entrepreneur, lucky in cards and love. Naturally, Lovejoy is intrigued, and soon the two strike up a conversation, not unlike the Granger/Walker "meet cute" from Hitchcock's *Strangers on a Train*.

Tyler eventually ends up in Slocum's hotel room listening to the braggart's grandiose plans and schemes, eventually realizing that his new bestie is a 100% sociopath. Bridges' offer of a decent paying gig encompasses being no less than a wheel man for a series of small-time robberies. At first Lovejoy is outraged, but soon is convinced that his plight is society's fault. He wanted a job, but no one else gives a crap about him, so WTF.

Soon bills are being paid, wifey is happy, and all is good. It's the new post-war American dream, with a couple of caveats.

Concurrently, the press, portrayed as self-serving journalists with an accent on the yellow, scares the public with local crime-wave articles, penned by a conflicted Richard Carlson. His boss, slimy Art Smith, couldn't care less, as each issue outsells the last.

Fuel feeds the fire, and small-timer Bridges now wants to up the ante. The something-new-has-been-added incentive is to kidnap a local rich kid (Carl Kent), collect a ransom and live on easy street. Lovejoy is appalled, but essentially

blackmailed into assisting, the promise of one last big payoff being a not-so-bad carrot. But did we say that Bridges is a sociopath? Oh, yeah, we did. "No witnesses" is the best solution to prevent capture, and a shocked Lovejoy watches as his partner lovingly slaughters the victim.

The guilt piles up, causing Lovejoy to drift into alcoholism and, finally (dat ole debil moon) insanity.

The public, revved up by the sensational reporting, forms a mob, intent to hunt and extract their own special kind of justice. And since the community is multi-racial...uh-oh, here we go...

In many ways, like Losey's extraordinary contemporaneous effort *The Lawless* (also available through Olive Films), **TRY AND GET ME** melds many progressive ideas (anti-capital punishment, affordable health care, decent pay) into a cohesive and literate narrative (much of it delivered by an admittedly preachy immigrant sociologist, enacted by Renzo Cesana). Based on the *The Condemned* by Jo Pagano, the script, by Pagano and director Cyril Endfield, is an almost

flawless primer on how to write a first-rate movie on a miniscule budget. Of course, it helps immensely that the cast and crew is no Z-movie company. Aside from the excellent thesps already named, the roster of A-1 players includes Adele Jergens, Harry Shannon, Kathleen Locke, Yvette Vickers, Irene Vernon and, in his cinema debut (as a lousy comic) Joe E. Ross. Hot cha! The pic was beautifully photographed on location in Phoenix, AZ, by Guy Roe (who previously photographed Sirk's exquisite 1946 *A Scandal in Paris*), and the music score is by the terrific composer Hugo Friedhofer.

Best of all is the tight, suspenseful direction by Endfield. It's likely his liberal ideas sealed his fate, as this was his next to last work before being blacklisted by HUAC, and forced to seek refuge in the UK (where he remained for most of the rest of his days, not surprisingly a close doppelganger of the aforementioned Losey's future). They sure tried to get him! Alas, our loss was Britain's gain. Once ensconced in England, Endfield strutted his considerable stuff by knocking out the first draft for the horror classic *Night of the Demon*, while embarking on a remarkable series of brilliant

movies in which he collaborated with actor Stanley Baker, including 1957's *Hell Drivers* and the 1964 classic *Zulu*.

TRY AND GET ME, under the original *Sound of Fury* moniker, performed disastrously upon its debut. UA quickly withdrew it, gave it the more exploitative **TRY AND GET ME** title, and let it loose again amongst the popcorn-munchers, where it bellied-up even worse. The movie was tossed into the *Joan of Arc/Ishtar* bin, where it essentially remained for more than sixty years, with only enticing pressbook snippets, amazing stills and poster art to whet noir/Endfield fans anxious *labiis*.

Thankfully, Olive Films has rescued this too-long neglected gem and given it the treatment it deserves. The 35mm elements are in fine shape with Blu-Ray bringing out all the stark black-and-white cinematography in stunning detail. Ditto the mono audio, particularly one grisly moment where the sound of raw steak being pounded in a diner is identical to that of Bridges pummeling Kent's head with a rock.

So, film noir aficionados, there's no reason for you to try and get **TRY AND GET ME**. Simply put, *get it*! And get it good!

TRY AND GET ME. *Black-and-white. Full frame [1.33:1; 1080p High Definition]. 2.0 DTS-HD MA. Olive Films/Paramount Home Entertainment. CAT # OF1195.*

LEAN STREETS 2: DRIVING FORCES

No doubt about it, vest-pocket noirs are gaining in popularity. Of course, this adjunct has long been made respectable by the ever-increasing reputation of Edgar Ulmer's *Detour* (1945), but, as we learned in *Lean Streets, Part One*, the studios, particularly the poverty-row ones, leaped aboard the noir bandwagon, due to the modest means (literally, as in limited lighting) required to create the dark universe that emboldens the rain-drenched nocturnal world that we've all come to love and admire.

That said, the major studios *also* realized that low-budget versions of their big-budget thrillers

provided an ideal cofeature (and, later, in the 1950s, a direct-to-nabe outing). RKO, in a weird reverse, even took the same property, *Farewell, My Lovely*, and did it as an "A" (*Murder, My Sweet*) and a "B" (*The Falcon Takes Over*), with the "B" version produced first.

Warner Bros., however, took it a step further by providing distribution for indie producers with the added incentive of giving them access to their contracted TV stars on summer hiatus. It was a win/win deal, as evidenced by a pair notable cheap pickups, 1951's **ROAD BLOCK** and 1958's **VIOLENT ROAD**, now on made-to-order DVD-R from the Warner Archive Collection.

A 73-minute smackeroo, **ROADBLOCK**, from RKO, is an underrated gem of textbook noir.

Since it's a movie *starring* Charles McGraw, I'm already a fan before the main credits finish rolling. McGraw is Joe Peters, an incorruptible insurance detective who, upon a chance meeting with gorgeous Jean Dixon in an airport lounge, becomes corruptible. Of course, the panting lust is reciprocal, but Dixon's Diane is first and

foremost an aberrant chiseler with ties to crime. McGraw, brilliant as ever, tries with all his might to stop thinking with body parts other than his brain...and fails.

The dialog in George Bricker's and noir veteran Steve Fisher's script (from a story by Daniel Mainwaring and Richard H. Landau) is quotable to the max. McGraw's honesty is methodically chipped away, as the unstable, irresistible Dixon chides him for being a bush leaguer (in every way): "You're not in my league. I'm aiming for the World Series."

But can't love conquer all? Dixon lays it (no pun) brutally on the line. Her "Someday you're gonna want something nice and expensive...that you can't afford on a detective's salary..." rings true, even though Joe admits he still "has to look at himself in the mirror." Ultimately, bewitched Joe admits to the seductress that he wants "you so bad, I can't think straight. You're what I want for Christmas, the day after the Fourth of July, Saturday nights...all the days there are." Holy moly, that's enough to have even a pro like Diane walking wobbly. Alas, before you can say "the

flesh is weak," McGraw is meeting with top mob kingpin Kendall Webb (Lowell Gilmore) and plotting a foolproof train robbery. Can Louis Jean-Heydt, McGraw's even more incorruptible partner (and in a rare good-guy role) set the score straight? I think we all know the answer to that. This is film noir, baby, and nothing ends well for anybody, save the audience.

I genuinely love this tense "B," one of the many great mini-noirs McGraw made for RKO (the trim budget omits the robbery altogether, a necessary decision that actually works toward the movie's pacing and success). Nevertheless, there are some excellent locations, particularly that great visual backdrop, the L.A. River concrete spillways (used so memorably in both *THEM!* and *Point Blank*).

The picture quality (superbly photographed by the studio's overworked artist Nick Mursuaca), from 35MM sources, is excellent; the mono audio veers a bit on the bass side, but not a problem (although there is a slight hum on during the final third of the pic, again, no big deal).

Swiftly directed by Harold Daniels (*Sword of Venus, Port Sinister, My World Dies Screaming*), and undoubtedly his finest work, **ROADBLOCK** should have genre fans crashing through all barriers to add it to their collections.

Laughing death in the face while hauling horrific cargo is truly a noir natural. Within the confines of the taut scenarios, all the aspects of the genre are there: wise-cracking tough guys, greedy dispatchers with ties to gangsterism, roadside whores, cheap diners, lots of smoking, drinking, fighting and (ominous music swells up) murder.

What jump-started the influx of truck pics in the 1950s can be tied to one movie in particular – and an import at that. I guess you know what I'm talking about – 1952's French classic *The Wages of Fear* by director Henri-Georges Clouzot. The narrative about down-and-outs risking their lives for high pay by transporting nitro over hazardous terrain filled international box-office coffers. In short, it rocked. The unshaven, pit-stained losers who populated this lowlife paradise made stars out of Yves Montand and Charles Vanel. It also enabled the talented Clouzot to thrill us again

with such subsequent suspense pics like *Diabolique*. It's very likely, however, that Clouzot and coscripter Jerome Geronimi (to say nothing of author Georges Arnaud) got *their* inspiration from Hollywood – and its unsung hero of movie trucker lore (or lorry, if you're British), Greek-American writer A.I. Bezzerides.

Bezzerides mined the potential of the underbelly of the hauling business with the spectacular 1940 Raoul Walsh masterpiece *They Drive by Night* (based on his 1938 novel *The Long Haul*). This landmark five-star/six-wheeler triumph costarred George Raft, Ann Sheridan, Humphrey Bogart and Ida Lupino; if EVER there was noir cast, this is it. Bezzerides, also known for penning the script to Aldrich's *Kiss Me Deadly*, followed it up with his first script *Juke Girl* (1942, also with Sheridan) and the underrated 1949 Jules Dassin classic *Thieves' Highway*, featuring Richard Conte and Lee J. Cobb.

These movies dealt primarily with the greed and mob element that we must assume genuinely fueled the actual industries. While the only peril regarding the cargo was time (perishable fruits

and vegetables), I still imagine that these flicks largely *did* influence Clouzot. Ironically, even *before* Bezzerides, there was a remarkable little RKO "B" that DID involve the high pay/adrenaline rush of transporting nitro – the rarely seen 1937 programmer *Border Cafe*, costarring Harry Carey and John Beal. Worth checking out, even if only for historical context.

By the time *Wages of Fear* hit the English-speaking countries on both sides of the pond scum, the gas was pumping hi-octane. 1957 saw no less than three B&W truck dramas. Least was Allied Artists' *Death in Small Doses*, which tackled the still headline-heavy dilemma of drug-addicted truckers, doping up to keep awake. Best was the UK unsurpassed celebration of high-testosterone, *Hell Drivers* – one of toughest pics ever. Written and directed by Cy Endfield, this relentless depiction of psychopathic machismo costarred no less that Stanley Baker, Patrick McGoohan and Sean Connery (with Herbert Lom, David McCallum and Sid James in support). Peggy Cummins, the maniac from *Gun Crazy* (and later the heroine of Tourneur's *Night of the Demon*) was the human prize coveted by the otherwise male cast – whether she liked it or not. It's a fucking great

movie (in VistaVision too). The other movie was an extraordinary Fox RegalScope noir entitled *Plunder Road*.

Mutha-trucker history lesson over. Here's where I was going:

1958's **VIOLENT ROAD** shamelessly rips off *Wages of Fear*, but gets by due to the excellent cast and professional Warner Bros. tech crew.

Directed by Howard W. Koch and produced by Aubrey Schenck, the picture was indeed a couple of rungs up the ladder from their previous UA deal, where the pair conceived a slew of low-budget crime, horror, western and rock 'n' pics under the Bel-Air banner.

In **VIOLENT ROAD**, **ROADBLOCK** author/script writer Richard Landau (adapting Don Martin's story) took Clouzot's work to a far more dangerous (and contemporary) level. No mere nitro in this haul, but rather way more lethal (as in radioactive) and volatile rocket fuel. This stuff is so deadly that the small towns dotting the route have sent out armed militias to block the three

monster trucks from even coming close to their burgs.

Driving the rigs are tough guys with pasts and the best credentials their unions can offer. And by that, we don't mean truckers, but rather Central Casting and SAG. Every cliché imaginable has been thrown into the mix. Star Brian Keith is the rebellious, womanizing loose cannon hired to spearhead the trek – getting that much-needed juice to the nearest launch site. Keith's character is really like old-school Warner Bros., taking bit of Jimmy Cagney here, a pinch of John Garfield there...you get it. The other grand hotel roster three-paired/six man crew comprise the sleazy gambler down on his luck (Arthur Batanidis), the fresh kid (Sean Garrison) living in the shadow of his once-idolized, now drunken older brother, the minority dude striving to earn enough to get to college (Perry Lopez), the burned-out cashiered military officer hoping to go out in a blaze of glory (Dick Foran), and the self-loathing nuclear scientist haunted by a horrific miscalculation (Efrem Zimbalist, Jr.). It's the latter two who are the most interesting – if only for their *Mad* magazine personal histories. Foran is part of

Foran & Doran, not a vaudeville team, but a mismatched spousal nightmare that has him hitched to the verbally abusive Ann Doran: "[You] get the free drinks, I get the hangover," she spits out as he stumbles home from a late night bender.

Zimbalist, however, wins the Carol Burnett movie parody prize hands down. Why would a revered nuclear physicist be reduced to hauling the stuff he helped create? Penance, my friends. You see, Efrem mistakenly chartered a live warhead missile into a local hamlet. Worse – ground zero ended up being the town's elementary school. And just as the kiddies were being picked up by their parents – including his wife (Merry Anders, decked out like Kim Novak) and daughter. Yup, he toasted them all. It's here that **VIOLENT ROAD** detours slightly off its *Wages of Fear* course and onto the perilous *Zero Hour* runway (the laughable air-disaster movie from the year before, and the source of 1980's *Airplane!).*

There's lots of action packed into the 86-minute package, highlighted by desert location work and some gut-wrenching suspense. To give you a taste – there are runaway rigs, twisted body part

mutilations (aka Lopez getting his arm snapped by an unforgiving gearshift), and, as if *Zero Hour* needed any more competition, there's even an out-of-control school bus headed smack-dab for a stalled tanker. **VIOLENT ROAD** is fun (and funny) and, while certainly no *Wages of Fear*, it's also never *not* royally entertaining.

What keeps it moving on an even keel is that the actors (who all seem to know this is unbelievable even for a B-movie) play it absolutely straight. While we mentioned a couple of the females sprinkled throughout (and heavily hyped in the trailers and ads), we gotta mention the babes who gather around Keith like he's the fornicatin' king of an adult 50s version of *Leave it to Beaver*. Prime among these prime-mates is Joanna Barnes, who slings it around as if she's that skanky third face of Eve, but dirtier. Of course, we instantly worship her – and her snarky bon mots, which she drops with great *bim*bardier expertise; dismissing Keith after a highway encounter in the backseat, she magnificently reveals him to be nothing but another love deposit, easily removed "...under a hot shower [that] wash[es] away...the dirt I picked up." The last image of Keith has him jumping into

a Thunderbird convertible, driven by a huffing-and-puffing accommodating babe of the Mamie Van Doren/Elaine Stewart variety. And that's some variety!

The crisp widescreen camerawork by Carl Guthrie is WB pro all the way, as is the churning score by Leith Stevens.

I might suggest pairing **VIOLENT ROAD** with the aforementioned *Zero Hour* for a riotous Fifties Nightmare Night. To quote Slim Pickens (who has nothing to do with ANY of these pics), it's "a hoot an' a holler." In reverence to more metropolitan viewers, the movie, like Joanna Barnes, will honk your horn.

ROADBLOCK. *Black and white. Full frame [1.37:1]; Mono audio. CAT # 1000477791.* SRP: $21.99
VIOLENT ROAD. *Black and white. Widescreen [1.85:1; 16 x 9 anamorphic]; Mono audio. CAT # 1000500722.*
Both are made-to-order DVD-Rs from The Warner Archive Collection/Warner Home Video.

Available from the Warner Archive Collection: www.wbshop.com/warnerarchive or online retailers where DVDs and Blu-rays® are sold.

ELECTION OF THE BODY SNATCHERS

Directors Raoul Walsh and Robert Wise never fail to throw me for a loop (maybe it's the "right/wrong" RW initials?). Just when I think I've got them pegged, up pop nine gazillion celluloid obscurities that I've never heard of. A perfect example is the latter's superb 1952 docu-noir thriller **THE CAPTIVE CITY**, now on Blu-Ray from Kino Lorber Studio Classics/20th Century-Fox Home Entertainment/MGM Studios.

A true story, **THE CAPTIVE CITY** is a genuinely frightening vest-pocket sleeper depicting the horrific events befalling journalist John Forsythe (in his big-screen debut) and wife/partner Joan Camden. Forsythe, as newshound Jim Austin, seems to be leading the ideal life. A no-nonsense reporter, he has taken an offer to edit (and co-run) his best friend's newspaper in the small, quaint town of Kennington, (located just outside of Anywhere, USA). It's a picture-perfect quiet

white (in every sense of the word) picket-fence life, peaceful, tranquil – ideal for raising a family and enjoying the 1950s post-war middle-class American dream.

Or so it seems.

Snarky, suspicious Forsythe is nonplussed when a down-on-his luck private eye (Hal K. Dawson) stumbles into his world with a wild tale of political corruption, murder and attempted assassination. Forsythe initially tolerates the ravings of this loon, but is jarred when the man (who claimed this all stemmed from a divorce case) is found dead a short time later. Forsythe decides to half-heartedly pursue the story, questioning the victim's terrified widow (Geraldine Hall). When the facts add up, Forsythe opts to blow the lid on the villainy within his township's midst. And then it starts. He and his wife are harassed by the local cops, businessmen, and the general Kennington citizenry.

WTF is going on here?

Soon the sinister Chief of Police (the always oily Ray Teal) grins a "knock it off" flesh-crawling

threat. In rapid succession, the Austins' world takes a sharp detour from Norman Rockwell to Norman Bates. The hellish situation spirals downward when Forsythe discovers that his best pal (Harold J. Kennedy), who got him the gig, is also "in on it."

But what is "it?"

In the wake of the Kefauver hearings, Kennington is revealed to be one of a myriad of idyllic little off-the-radar hamlets that factions of organized crime took over. Mob kingpins poured big bucks into the local businesses, helped elect the officials and kept the populace comfortably solvent while they used the burgs as hide-in-plain-sight vicinities to perpetrate money laundering, drug and prostitution drop-off revenue points, and, for the icing on the cake, grab a piece of the action of the more successful legit concerns. It's a McCarthyism offshoot at its most heinous, or, as Teal refers to the embracing of conformity: "...giving the people what they want."

This is a real-life *Invasion of the Body Snatchers*, and, thus, all the more harrowing. Coupled with

violence and stark documentary style filming a la *The Phenix City Story* (but made a years before either), **THE CAPTIVE CITY** is a template for top-notch low-budget movie-making; in short, a pic that totally deserves to be discovered (I'd say rediscovered, but I don't believe most folks have ever had the chance to find it in the first place). This nail-biter is a twentieth-century shocker of the highest order, an effort that Wise's former boss, Val Lewton, would have no doubt proudly approved of. The non-phantasmagorical chills are not only Lewtonesque, but even prefigure the director's 1963 explicit supernatural Grand Guignol masterpiece *The Haunting*. The fact that this all happens in broad daylight, amongst smiling faces of "turned" neighbors, makes the proceedings all the more nasty.

One sequence of Forsythe being tailed by an ominous sedan is creep-out marvelous. The slow-moving vehicle, stealthily stalking its prey, atmospherically undergoes a transformation from automobile into fearsome monster (its grillwork, appearing in full sardonic grimace, is almost reminiscent of a Paul Blaisdell creation). As Camden begs her husband to justifiably flee the

hellish community ("I don't know if I want to live like this. This is Kennington, not Chicago!"), Forsythe, in full agreement, plots their exit. They've been targeted – change or die. The couple's escape (which serves as the framing story) is a paranoid's dream, or nightmare. Can they make it to the next town's police department? But, wait a minute. What if that community has been corrupted too? And the next town. And the next. How far has this malignant disease spread? No less than Kefauver himself makes an appearance to verify the events in this movie as being 100% authentic, which makes it 110% scarifyin'. Supposedly, the "Austins" did live to testify, and were spirited away into some sort of witness-protection-program where we hope they prospered and survived.

THE CAPTIVE CITY, while filmed on a shoestring, has formidable credentials. Aside from Wise and the excellent script by Alvin M. Joseph, Jr. and Karl Kamb (based on a story by Joseph), **CITY** was photographed by the great Lee Garmes, and contains a wonderful score by Jerome Moross. Aside from the aforementioned thesps, the terrific supporting cast includes Victor Sutherland

(excelling in loathsome viciousness), Martin Milner, Marjorie Crossland, Ian Wolfe, Paul Newlan, Paul Brinegar and Gladys Hurlburt. Wise was deservedly elated when the few people familiar with this movie would ask him about it. He happily recounted that the entire pic was shot on-location (interiors and exteriors) in Reno, Nevada, without one studio insert, and in less than three weeks.

The Kino Lorber Blu-ray looks and sounds great, with crystal-clear monochrome imagery to match the wild sound audio. I suggest double-billing it with Siegel's 1956 classic, provided you screen the sci-fi version first (it makes the real thing, which I'm convinced that *Body Snatchers* writer Jack Finney must have seen, come off way freakier).

THE CAPTIVE CITY is one of Robert Wise's finest movies. It's a shameful example of a "fallen-through-the-cracks" project that, thanks to Kino Lorber Studio Classics, can now be deservedly excavated.

THE CAPTIVE CITY. *Black and white. Full frame [1.33:1; 1080p High Definition]; 2.0 DTS-HD MA.*

Kino Lorber/20th Century-Fox Home Entertainment/MGM Studios. CAT# K1942.

LADY-O-ACTIVE

Film noir fans are in for an unexpected treat with the twisty, delightfully sordid 1954 thriller **WORLD FOR RANSOM**, now on Blu-Ray from Olive Films/Paramount Home Entertainment.

An early Robert Aldrich effort (in fact, only his second big-screen endeavor following the baseball drama *Big Leaguer*), **WORLD FOR RANSOM** was the result of his bonding with star Dan Duryea. Duryea had just finished a short-lived action series, *China Smith*, several episodes of which were directed by Aldrich. The idea of doing a progressive suspense adventure utilizing the still-standing *China Smith* sets intrigued Duryea and he signed on. Aldrich, who acted as coproducer, did the rest, assembling the cast and crew and quickly putting the actors through their paces in eleven days, and for a total cost of under $100,000.

The result is one of the strangest noirs viewers are ever likely to see. Suffice to say, it's also one of the strangest action pictures, one of the strangest adventures and one of the strangest love stories (extra sauce on the latter).

The 83-minute tale of intrigue and double-crossing was scripted by Lindsay Hardy (with uncredited assist from Hugo Butler) and revolves around one of the director's pet themes: the ultimate price to be paid for monkeying around with atomic warfare. In this respect, it prefigures his subsequent triumphs *Kiss Me Deadly* and *Twilight's Last Gleaming* – but there embryonic rumblings that would erupt full-force in many of his other later classics.

Duryea plays the mysterious Mike Callahan, a soldier of fortune with a dubious reputation for playing both sides of the fence. The "both sides of the fence" pattern is a major part of the story, as the audience will learn with a breathless gasp.

Even for a film noir character, Callahan wanders through the seamy, steamy nighttime Singapore streets with a disturbing "who cares?" abandon.

Indeed, as depicted in **WORLD FOR RANSOM**, the infamous Asian city is *such* a noir town that even the interiors are awash with thick, swirling fog.

Callahan is despised by both sides of the law, each of whom, at various points of the movie, beat him mercilessly. "You really got a hoodlum touch," he honestly tells the chief of police in one of the pic's plethora of great lines indicative of the genre.

The core of Callahan's malaise is his being screwed over by his one-time pal and partner Julian March, a particularly slimy Patric Knowles – picking up from where he left off in Don Siegel's *The Big Steal*. What really got Callahan's goat was that the biggest crime March ever committed was stealing and marrying his former (and only) true love, Frennessey, a beauteous *chanteuse*.

Callahan's eternal bitterness is sweetened when Frennessey calls him out of the blue, wanting to hire him to find out what her disreputable spouse is up to. Callahan jumps at the chance, hoping to get the goods on the bum and ruin him in the

eyes of his beloved – thus winning her back. The fool! Frennessey is amused by Callahan's aspirations, and shrugs off the many infidelities she has suffered due to hubby's womanizing. She just wants to find the slob.

No doubt March is up to no good, but, oh, *what* no good! It's beyond even Callahan's wildest nightmares. He's aligned himself with Alexis Pederas, a sinister bastard, portrayed by the usually likeable Gene Lockhart.

March, impersonating a British officer, kidnaps brilliant nuclear physicist Arthur Shields (yeah, I know), who is armed with the plans for the new, improved A-Bomb – the H-Bomb.

In walks Lockhart to Governor Nigel Bruce's office (yup, Nigel Bruce in his final screen role) and calmly demands $5 million in gold, or he's offering the goodies to folks behind the Iron Curtain.
Believe me, there's nothing better than hearing the cinema's beloved bungling Dr. Watson mouth off about the horrors of nuclear warfare to cohorts Reginald Denny and Douglass Dumbrille.

There were, I say unabashedly, tears of joy in my eyes.

How Duryea infiltrates these baddies (including a frightening Lou Nova) and apathetically triumphs (all in the name of love) is the picture's crazed wrap-up. The magnificence of Duryea's thespian chops are on full display here as he spectacularly reveals that what happens to the world is of little importance to him – he just wants his dream babe back.

The violence in **WORLD FOR RANSOM** is trademark Aldrich, and, by that I mean shockingly graphic (especially for its time). Jungle fighting, sanguine skewering, innocent bystanders offed without hesitation...It's a bloodbath at its most unhygienic. The attack on the kidnappers' compound resembles a low-rent run-through for the climax of *The Dirty Dozen*, and is almost as exciting.

But the true horror is not the post-war end-of-the-world possibilities, but what awaits Callahan and his anxious reunion with Frennessey.

Alone in her room with the singer, Callahan describes with relish the evil of her now-exed ex. She sneers it off, and when Callahan makes his move to rekindle a flame, he's met with one of the most vicious bitch-slaps in all of cinema. This physical response, however, no way matches the verbal anger that spews forth from the lady's lips. She tolerated and even encouraged March's cheating because he left her alone. "He got me!," she screams. "Accepted me for what I am." Duryea (and, presumably, the audience) is (are) to take this as meaning a whore. Nuh-uh. Frennessey has an H-Bomb of her own. She is repelled by men, and adores the pleasures of her own sex. Duryea's realization is seen by the look of "suddenly-it-all-makes-sense" terror in his face, most likely underlined by earlier sequences of her singing in a nightclub where female performers tend to dress like Marlene Dietrich in *Morocco*.

An even-more disillusioned Callahan staggers out into the rain-swept streets, disappearing into the night as sultry procurer May Ling taunts sailors outside the Golden Poppy with "Love is a white bird, yet you cannot buy her." I tell you, this movie is a peach!

The iconic noir theme of double-cross is practiced with a vengeance throughout **WORLD FOR RANSOM**. Callahan has alternate identities, sometimes known as Corrigan. Knowles impersonates officers. Cops act like thugs, thugs act like ruthless government diplomats, and Frennessey...well...

With his second feature, Aldrich is already at the top of his game, and, with his key crew in place: d.p. Joe Biroc, editor Michael Luciano and composer Frank DeVol. A teasing ballad about the perils of falling in love without your peepers open, appropriately titled "Too Soon," was written for the picture by Walter G. Samuels.

Marian Carr, who is introduced in **WORLD FOR RANSOM** (and appeared on episodes of *China Smith*) is the berries as Frennessey. Aldrich thought so too, and later cast her in *Kiss Me Deadly*. Other welcome faces include Keye Luke, Patrick Allen and Strother Martin. Of course, it's the great Dan Duryea who dominates the proceedings; it's always cool to see this noir master starring in a movie – and in this one he's got a lot on his plate. Cold War plotwise, he's akin

to Richard Widmark in Sam Fuller's *Pickup on South Street* (and, natch, Ralph Meeker in *Kiss Me Deadly*), except here, it's pure love that floats his boat, and not the almighty buck. What a sap!

The movie is a catalog of Aldrich visual insanity – dutch angles, creepy moving camera, comically-framed imagery of visceral events...It's all here and more. As indicated earlier, the dialogue perfectly complements the foreboding compositions. For example, upon hearing a wacky Chinese name, Callahan, in a rare moment of levity, quips, "There's a pun there somewhere."

The Olive Films Blu-Ray, comes from generally excellent 35MM materials. Picture quality is format prerequisite razor-sharp and the mono audio crisp and clear. Originally released through Allied Artists, **WORLD FOR RANSOM** is a must-see little pulp gem that horrifically lives up to its title. Did I say "peach"? It's a honey of a peach!

WORLD FOR RANSOM. *Black and white. Full frame (1.37:1; 1080p High Definition). 2.0 mono DTS-HD MA. CAT # OF882.*

CAF-FIENDS

The ultimate filmic depiction of the term "just desserts" (assuming one enjoys their after-dinner treats with a cup of joe) **THE BIG HEAT** returns to Limited Edition Blu-Ray, courtesy of Twilight Time/Sony Pictures Home Entertainment.

We're, of course, enthusiastically praising not only the joys of film noir, but, particularly, the merits of this 1953 seminal example of the genre at its peak. It's sort of silly to explain the plot at length; I mean by now the movie is practically a part of our national culture. The Sydney Boehm screenplay (from the William P. McGivern *Saturday Evening Post* serial), wrapped around the standard scenario of a wronged dedicated cop out to smash the corrupt system, is typical noir fodder. The bizarre manner in which the loose ends are tied up is what gives **THE BIG HEAT** its jamocha punch. 110% of this hellish detour's success belongs to the pic's director – the near-mythic, equally hellish Fritz Lang.

What attracted Lang to the project is the one aspect of **THE BIG HEAT** that everyone remembers: the unusual deadly weapon that several characters are assaulted with. Granted, the big heat of the title can apply to the intensity of the widespread political corruption spread throughout the narrative...or the numerous instances of gunplay...or the fact that the lead's wife gets fried in a car-bomb gone awry...For me, and, as I suspect, for Lang as well, the title refers to the use of cinema's strangest lethal equalizer, the pre-cursor of Mr. Coffee.

Now, coffee as weaponry or simply a torture device certainly sounds unique; for Lang this was essentially business as usual. One must bear in mind that this was the same guy who terrified confused film producers with his idea for a horror movie wherein vampires came out of televised video receivers to conquer their human victims. While this is undoubtedly an outrageous premise, it becomes even more so when one realizes that the director suggested this to the boys at UFA in 1918 (thus beating the Japanese to *The Ring* by more than 80 years!). Then again, Lang is also the

dude who, in cahoots with lover and future spouse Thea von Harbou, has always been suspected of murdering Lisa Rosenthal, his first wife...who later lived a *Sunset Boulevard* existence in semi-decay, regaling an ongoing barrage of starlets and hookers with his extreme sexual demands, while his Nurse Ratched-like attendant (brought over with him from Germany where, depending upon whom you believe, he A) escaped to freedom or B) turned down Nazi generosity from the talons of Adolf & Co.) presided over their nominal needs. That this crumbling no-nonsense health provider was later revealed to actually be Lang's third wife, adds that extra spice to the already aberrant mix.

Bride number three, it should be noted, goes back to Lang's obsession with Marlene Dietrich – which actually began before Marlene became Marlene, in 1922 when Fritz shot graphic full-frontal scenes of Anita Berber for *Dr. Mabuse the Gambler*. Berber, who was, in essence, Dietrich's role model, expired before the end of the decade, but UFA elders long recall Lang's specific demands on what color to dye her pubic hair for these

sequences, knowing all-too-well that they would be tossed into the refuse bin. Lang finally had his way with Marlene during the production of the 1952 western *Rancho Notorious*; it was a short-lived affair that Dietrich vehemently denied existed in that age-old tradition of "the lady doth protest too much." Personal photos retrieved after the director's passing showed much 1930s-era cavorting betwixt the Teutonic twosome...until closer examination revealed that the "Marlene" in the pix was really the soon-to-be long suffering nurse (an actress ironically christened with the big-heatish moniker of Lily Latte) before decades of abuse stole her looks, and, in all likelihood, a reasonable portion of her sanity. Their tale of one-sided unrequited love eerily resembles the exploits of the infamous Vampire of Dusseldorf, Peter Kurten, whose wife frequently accompanied him during his 1920s reign of terror – acting as his one-woman support group/mop-up crew. Claiming hundreds of victims before being caught and executed, Kurten was the template for the Peter Lorre character in Lang's immortal 1931 masterpiece *M*.

By comparison, a bubbling pot of hot coffee in the puss almost seems a mild choice of vengeance...in fact, more like a capo's cappuccino or a wicked designer latte on the rampage.

The non-liquid star of **THE BIG HEAT** is Glenn Ford – and he's pretty good as the honest-to-the-point-of-maniacal flatfoot. Ford is sort of like a kinder, gentler version of the lunatic from Sidney Kingsley's *Detective Story*, but way less corny than the movie version's Kirk Douglas. Ford, father of a remarkably normal little girl, is married to creepy Jocelyn Brando. My use of the word "creepy" is in no way a thumbs down critique of Ms. Brando's adequate acting abilities...It's just that...well, as the sister of the far more noted Marlon, she...how can I say it? SHE LOOKS LIKE BRANDO IN A DRESS AND WIG! I must shamefully confess that for years I told gullible movie-lovers that Jocelyn really didn't exist – that she was Marlon's alter ego...appearing in drag in a moderately successful second career. And they believed me. Brando does seem to satisfy the easily enraged Ford (another "heat" reference) – pacifying the copper with both her girl-next-door

carnality and the ability to cook him meals featuring the biggest baked potatoes I've ever seen. Lang's obvious contempt for the goody-goody wife is evidenced by her shocking firebomb death – shot in virtually the exact (to use a Brando-related term) method as Oliver Hardy lighting the stove in *Blockheads*.

THE BIG HEAT is filled to the brim with lust and passion; it's a female-fueled sexual drama. Jeanette Nolan is the harpy wife of a deceased high-ranking police official who holds the local gangland hostage; she might be the movie's strongest character if it wasn't for the movie's strongest character – nympho gun moll Debbie, brilliantly essayed by the magnificent Gloria Grahame in noir's most iconic siren performance. Hell surely hath no fury like a woman scorned – more so for a woman scalded. Grahame, who has the misfortune of being psycho-thug Lee Marvin's squeeze, is the victim of a plethora of physical and verbal degradation, which, she often appears to actually crave. This was a bold undertaking for a 1953 movie. Although Deb has to pay the price, it's still a

bargain for viewers watching the decades-old production code seemingly evaporate as the 90-minute running time is unspooled. Grahame is not only the recipient of **THE BIG HEAT**'s hottest and violent scene, she also has the best lines. "Whenever Vince [the Marvin character] talks business, I go out and get my legs waxed" she boasts to an unimpressed Ford. Evaluating the modest hotel room the now-ex-detective is resigned to living in, Grahame tosses off her apt evaluation, "Hmmm...I like it – early nothing." Once disfigured by America's favorite boiling beverage, bad girl Grahame in effect becomes Java-the-Slut, utilizing the taste treat to extract her own deliciously planned revenge.

We can't say enough about Lee Marvin either; **THE BIG HEAT** was a ground-breaking role for the actor, forever locking him into 1950s villainy. This is the first movie where the actor displays his patented hanging drop-jaw look (the Italian posters prominently feature him as some gangster version of *Nosferatu*). He has some nifty dialogue too; when describing Debbie to his cohorts, he tersely synopses her in a one-

line knock-off: "Six days a week she shops – on the seventh she rests."

So much of the dialogue was eyebrow-raising for the *Howdy Doody* generation. There is double-take-worthy discussion of psycho sex crimes (not surprisingly, a Lang-friendly topic) visually punctuated by pathetic hooker (here referred to as B-girl) Lucy Chapman's (perennially sad actress Dorothy Green) ravaged nude corpse, which investigators are told was unearthed covered with "...cigarette burns on her body." Then-starlet Carolyn Jones, too, becomes a subsequent human ashtray, or, to be blunt, a butt for butts. Obscene phone calls received by Brando ("...you can fill in the four-letter words") comprise an audible event never before witnessed in American cinema with the possible off-camera participation of Henry Hathaway. And, finally, the murderous confrontation between Grahame and Nolan is succinctly and accurately encapsulated as a queen of the jungle battle of "...sisters under the mink."

Alexander Scourby, the big boss of **THE BIG HEAT**, is fairly ineffectual in his reign – outclassed by the flick's powerful women. A large portrait (presumably his mother, and, in actuality, actress Celia Lovsky from God-knows what other Columbia Picture) dominates his office; Scourby is nonetheless appropriately oily, much resembling fellow Columbia crime czar Morris Carnovsky in *Dead Reckoning* (with a tincture of Harry Cohn but a touch more finesse).

Lang's reliance on heroic crippled dregs recalls his UFA period; again, here it's a woman – actress Edith Evanson – a literal personification of a junkyard dog (she works in a city dump).

Much despised by his contemporaries (crews constantly devised ways to kill him, a popular plan being to drop a Klieg light on his head), Lang nevertheless did have some ardent supporters. Ford and Grahame would be reunited with the director the following year for an adaptation of Jean Renoir's 1938 thriller *La Bete Humaine* – released in 1954 as *Human Desire*. Sylvia

Sidney adored him; after her death, the actress's apartment was found to be littered with photos of Lang, the most prominent adorning her refrigerator. George Sanders was always ready to work with Fritz, as was Joan Bennett, who, along with husband, Walter Wanger, went into partnership with the director. Edward G. Robinson and Dan Duryea likewise followed suit.

Upon its release, **THE BIG HEAT**'s reception was, climate-wise, tepid; critics pegged it as a distasteful standard ground-out piece of claptrap; the movie-going public, always more savvy than the stale aging members of the Fifth Estate, saw the worth in the piece – making it a modest box-office favorite.

Lang, constantly on the forefront of technological advances, chose to record the movie in stereophonic sound (the tracks unfortunately now lost), which presumably underlined the gat usage, explosions and, no doubt, mocha-java sizzle (the aforementioned *Human Desire* would be one of

the first Columbias in the new 1.85 widescreen process).

The 2012 TT Blu-Ray 4K-scan of **THE BIG HEAT** was hands-down the best copy I've ever seen – each Charles (no relation) Lang shot looking like a large format studio still. The soundtrack was crisp and dynamic (although I wish they'd have found that stereo!). The music is ho-hum, mostly relying upon the house themes arranged by nefarious Gower Gulch employee Mischa Bakaleinikoff. Actual original bits were composed by uncredited Henry Vars, auteur of *Chained For Life, Love Slaves of the Amazon, The Leech Woman, House of the Damned* and *Flipper's New Adventure* (but admittedly also Budd Boetticher's *Seven Men From Now* and Frank Borzage's *China Doll*). There are some nice nightclub accordion and guitar themes, so indicative of the decade, including a subtle homage to Ford via a rendition of "Put the Blame on Mame," the song from his noir triumph with Rita Hayworth, *Gilda*. All of this is accessible as an IST (Isolated Score Track), if one feels the need for Lang-like desecration. That this terrific

platter quickly sold out (becoming an eBay Big Bucks seller) is not surprising. Noir and **HEAT** fans can rejoice, as this 2016 Encore edition retains the former superlative transfer; but there's added incentive for purchasing the disc, as, unlike its earlier rendition, this redux comes with a stash of extras, including individual takes on the movie by Michael Mann and Martin Scorsese, plus audio commentary by cine-historians Nick Redman, Julie Kirgo and Lem Dobbs (natch, there's the IST option and the 1953 trailer, the latter which graced the 2012 version).

The appeal of **THE BIG HEAT** grows more ravenous every year. It's now deservedly considered one of the top noirs of all time. When, in eons past, I used to cite it as a humdinger, folks would respond to the title with a blasé "Qu'est-ce que c'est?" Happily, the movie's fame has now changed this reaction to Nescafe. But, you know, there's an additional pensive perk to watching **THE BIG HEAT** that seems to transcend its genre roots. I sometimes think (perchance too hard) of the people that made it happen, a kind of Unholy Three covenant. I think of Lang in his twilight

years, nearly blind, still guarded by Lily, his wizened Dietrich clone, carrying on one-sided talks with an ever-present toy sock monkey. He would sit in front of a non-vampire invading TV set, anxiously awaiting the next episode of his favorite show, *Green Acres* (he wasn't alone – it was Orson Welles' favorite too). I think of Gloria Grahame, whose torrid affair with Nicholas Ray resulted in a pregnancy and loveless marriage – culminating with her seducing Ray's teenage son (whom she later wed)...I think of Ford – for over a half century regaling listeners with his grueling account of being one of the first G.I.s to enter a concentration camp at World War II's end – a shadowy life-changing tale that, after his demise, was shown to be a hoax (he served in the war, but never left the States). I wonder if he had ever realized that sensitive, somber, troubled Glenn Ford was the greatest performance of his career. Perhaps it's just them – though **THE BIG HEAT**, more than any other mean-street movie, has always made me ponder about the dark side in all of us. Or maybe it's all a load of crap...Hey, I could use a cup of coffee...I'll take it *noir*...no milk...no cream...*and not in the face.*

THE BIG HEAT. *Black and white. Full frame [1.33:1; 1080p High Definition]. 1.0 DTS-HD MA. Twilight Time/Sony Pictures Home Entertainment. Cat #* 8-11956-02100-7.

Limited Edition of 3000; available exclusively through Screen Archives Entertainment [www.screenarchives.com] and Twilight Time [www.twilighttimemovies.com].

PULP FRICTION

Film noir fans need to momentarily stop running down those nocturnal rain-swept streets, catch their breath and rejoice for the Blu-Ray release of Don Siegel's vastly underrated 1954 crime thriller **PRIVATE HELL 36**, now available through Olive Films/Paramount Home Video.

An Allied Artists special, **HELL** contains what is likely the perfect noir cast. In the four leads are Ida Lupino, Steve Cochran, Howard Duff and Dorothy Malone, with Dean Jagger, Dabbs Greer, James Anderson, Richard Deacon and King Donovan admirably shouldering their always-appreciated support.

The plot (by costar/producer Lupino and her then-husband Collier Young, for their Filmmaker's Presentation company) is a peach. I've-got-your-back no-nonsense official City of L.A. gumshoes Cal Bruner and Jack Farnham (Cochran and Duff) genuinely enjoy their work, and its middle-class rewards (along with Scott Brady and Charles MacGraw, they are the perfect plainclothes candidates for a fantasy version of James

McElroy's *Black Dahlia*). This includes the violent part (a right-off-the-bat lethal skirmish in a convenience store is jaw-dropping and serves as splendid precursor to director Siegel's "Do ya feel lucky, punk?!" sequence in *Dirty Harry*). The schism between them is that Farnham can shrug it off after-hours, enjoying suburban living with his curvy, loving spouse Francey (Malone). Bruner, on the other hand, when not barbecuing with the Farnhams, contemplates a larger-than-life existence – one he feels he truly deserves, being better than most everybody (he'd never admit it, but he's kinda a perfect Nazi). Not surprisingly unmarried, Cal haunts watering holes, eventually hooking up with barfly/singer/whore Lilli Marlowe (Lupino), who, despite her circumstances, is a pretty decent person, striving for something better.

PRIVATE HELL 36 (the "36" being a secret locker) would never progress further than the interesting level, if it weren't for the dark, talon-fingered hand of fate. A wild car chase with a mob figure on the run results in his demise. Calling in the fatality along a deserted, rural road, Bruner and Farnham

discover a suitcase with $300,000.00 in stolen mob money. Jack is all for turning it in; Cal has other plans, and suggests an alternative. NOTE to all *noiristas*. NEVER take advice from Steve Cochran. Farnham is reluctantly convinced, and from here on their troubles escalate, notably when Bruner's increasingly overt psychopathic tendencies, veering frighteningly toward paranoia, go full Fred C. Dobbs on Farnham's ass. Plus, we have the police (led by narrator Jagger), already suspicious, and anxious to vanquish the force of dirty cops. PLUS, that pesky mob isn't about to write off their losses either. Jack and Francey thus become the archetypical genre poster couple for the hopelessness walls-closing-in scenario that, as we all know, cannot completely EVER end well. And it doesn't.

PRIVATE HELL 36 is one of my all-time favorite noirs, and, in my opinion, one of Don Siegel's greatest pics. Siegel, as recounted in his superb 1993 autobiography, *A Siegel Film*, considered it a mess. The reason being that producer-writer Lupino tried to also become director Lupino; it additionally didn't help that, aside from Dean Jagger and himself, the four leads were mostly

drunk throughout the shoot. Ultimately Siegel, who called it a "family film" (Lupino and Collier Young had been husband and wife) concluded "I liked Ida personally, and admired her talent. We just couldn't communicate." Siegel's "family" comment had an ulterior, cynical meaning, as three years previously Lupino divorced husband Young (who still remained her business partner), marrying Duff.

Off-camera keg-party hijinks aside, I still love this movie. The snarky, gritty script is peppered with quotable lines, many reflecting the then-current mainstream culture ("I've seen all this on *Dragnet*," spouts one cynical denizen about the daft, ferocious chain of events). Cochran takes the honors for the best lines, specifically when offering his personal exoneration to his far-more reputable-partner for their murderous deeds ("Stop taking it so hard. He wasn't your brother."). And watching all these scene stealers interact with one another is pure mean street joy.

All of the above is compounded by the downright brilliant black-and-white widescreen

cinematography of Burnett Guffey. Ditto the ominous score by Leith Stevens.

The Olive Films Blu-Ray does this unfairly ignored freak show justice, with a spiffy-looking platter, that, apart from slight grain, is a monochrome winner.

Tough, rough and oozing with guilt, **PRIVATE HELL 36** rates a key spot on your crazy-ass cop noir sidebar shelf, alongside *On Dangerous Ground, The Prowler, Kansas City Confidential* and the rest. Don't miss it.

PRIVATE HELL 36. *Black and white. Widescreen [1.78:1; 1080p High Definition]; 1.0 DTS-HD MA. Olive Films/Paramount Home Entertainment. CAT# OF456.*

WILDE IN THE COUNTRY

It's a testament to the DVD/Blu-Ray format to be able to rediscover an obscurity from those late-night TV daze of yore, and realize that you love it. Faint memories of strong scenes swirled around my so-called fertile mind for decades before I connected the dots that formed the rarely seen 1955 film noir **STORM FEAR**, now on Blu-Ray from Kino-Classics/Metro-Goldwyn-Mayer Studios/20th Century-Fox Home Entertainment.

The movie is a claustrophobic, bold undertaking for triple threat star/producer/director Cornel Wilde (his first directorial effort, btw), bold as it contains no adult characters worth championing. It underlines von Stroheim's belief that "life is a sewer," which is also a grand name for a musical.

During a treacherous December winter, in the rural wilderness of Idaho, the bleak Blake family ekes out their existence as fairly unsuccessful farmers. As handyman/childish gun nut Dennis Weaver goofs off with his employer's son (aka, teaching him how to shoot to kill) in a rising snow bank, the sprout's mom (Jean Wallace) spurs his

hired-help ass toward town for supplies before an upcoming storm does its worst.

Wallace and the child (David Stollery) endure the most minimal definition of the human condition, due to husband Dan Duryea's near-terminal tubercular condition (until effectively cured, he must reside in a high-altitude, clear-air environ). Duryea is also a struggling author, who, aside from t.b., is battling a fatal case of writer's block. Duryea's moodiness is concurrently repellent and justifiable – a remarkable achievement for an equally remarkable actor. Despite his acrimony, he truly loves his family. It's the world he hates,
and curses the fact that his young wife is becoming dowdy before her time (well, as dowdy as Hollywood allows beauties of the Jean Wallace calibre to depreciate, which is somewhere between 1970s Lois Nettleton and Lola Albright). Damn, things just couldn't get any worse!

And then they do.

From out of the snowy Currier and Ives landscape bursts an ungainly trio of urban dwellers: Wilde, Lee Grant and Steven Hill (in his screen debut).

Wilde is Duryea's estranged kid brother, Charley; he's also the leader of a band of killers who have just stolen eighty-five thousand dollars after murdering anyone who had the temerity to get in their way.

This is an indeed complex congregation of losers. Wilde is a charming, lying sociopath (so good that the stories/arguments he tells to win over the gullible and vulnerable Blakes are never quite proven to be true or not). Grant is a goofy, likeable (but obviously potentially lethal) ditz who apparently shops at Victoria's Floozie. Hill is a dyed-in-the-wool psychotic, itching to kill anything that moves, yet terrified of Wilde, who has the additional impediment of having been wounded.

So far, **STORM FEAR** comes off as a strange combination of *The Desperate Hours* meets *The Country Girl* meets *Key Largo*. Which isn't a bad thing. But as all intimate relationships tend to be: it's complicated.

At first Duryea's increasingly seething hatred of his

brother seems like a Bizarro World version of sibling rivalry, but there's reason for it. Son David's (yeah, that's his character's name too) beloved pet dog, a gift from Wilde, was shot dead by Duryea. This extreme reaction becomes a bit clearer when the canine reminder of his bro's influence is further sketched out to reveal that Wilde is actually the father of the child. No love, pure lust. And it looks as if tingly Wallace is about to once again cave to nature's call of the Wilde. Unlike Grace Kelly in her Oscar-winning role, all Wallace has to do is swath her pan with a swatch of lipstick, shake her hair loose, and VOILA!: instant goddess. Her aching loins are quickly sated as Wilde's initial rebuff turns to rape, both halted by interruptions from one or all of the other inhabitants. Wallace is genuinely quite effective in her "WTF was I thinking?" moment. David, meanwhile, is confused by the origin of his late pet, due to Duryea's cryptic and wicked "your father sent it" poisoned bon mots.

Concurrently, news of the killers' bloody trail is revealed on the radio along with reports of a record-setting nor'easter about to descend upon the community. Sickly Duryea, who is repeatedly

punched in the gut by the sadistic Hill (whenever Wilde isn't around), doesn't respond with as much anguish as when he gets his publisher's latest rejection letter. This is truly one of the cruelest moments in the movie, as it's likely the nastiest FU correspondence a writer has ever received (and I speak from experience). That said, there's a particularly harrowing scene where Wallace removes the bullet from Wilde's injured leg (mercifully, not with her teeth) that underlines her fading concern with a per verse, vengeful bravado.

And, yet, there are some amazing lighter moments in **STORM FEAR**, most prominently when Stollery attempts to have Hill commune with nature (a forced lifestyle the boy has come to cherish). He hands the thug a sprig of pine, asking him to take a whiff and appreciate its total beauty. Hill complies, retorting with a perplexed "Smells like a tree!" Of course, this is pure Wilde, a hardcore environmentalist, who further expanded on his ecological bent with his subsequent pics, *No Blade of Grass* and his authentic classic *The Naked Prey*. Another hoot is Grant's offer to help out in the cabin as long as it doesn't ruin her nails.

And thus, we're prepared for the final act of this suspenseful, violent adventure – a grueling foray through the remnants of the hazardous blizzard (Wilde has duped the boy into leading himself, Grant and Hill through a short-cut escape route over a mountain to the main highway). And, trust me, anytime you expose three New York Jews to the elements without any chance of a nearby noshery, you're asking for trouble!

Cornel Wilde is truly to be commended for his backpack overload of work on **STORM FEAR**. While Tony Mann, Nick Ray or Joseph H. Lewis (who the same year helmed the brilliant noir *The Big Combo*, also with Wilde and Wallace, and reviewed elsewhere in this volume) might have fleshed out the nuances of the characters a bit finer, the actor-turned-filmmaker delivers a most admirable debut. Personally, I found the unabashed grittiness and noirish hopelessness of the movie kin to the directorial efforts of Ida Lupino. And that may not be an accident. Wilde and Lupino, both liberal progressives, bonded during the filming of *Road House* in 1948. It's quite possible that Wilde may have discussed this project his with former costar before filming

126

commenced (there are visual similarities to *On Dangerous Ground*, which Nick Ray confided to me was partially directed by Lupino when he fell ill). To Wilde's credit, he has chosen some incredible talent on both sides of the camera to enact their craft. Both Grant and Hill are terrific (although top thesp kudos definitely go to Duryea), as is the thundering score by Elmer Bernstein (which includes a haunting harmonica suite). The stark but luxurious widescreen black-and-white location photography by the great Joseph La Shelle is aces. Ditto the tight take-no-prisoners screenplay by future *To Kill a Mockingbird*-scripter, Horton Foote (from Clinton Seeley's novel). The insidious persona of Wilde's character can never be thoroughly analyzed, as we never know if what he says can be trusted (a horrible tale of abuse by corrupt cops told to Stollery may be absolute bullshit). And you really do want to believe his sorrowful kidnapping adieu to Wallace regarding her son: "We don't want to do this, but we can't help it." Likely, though, as Wallace surmises, the boy is just another example of Wilde's panache for using people. It's these spine-tingling traits that easily add the character to the big and little screen's foreboding catalog of

frightening Uncle Charleys, firmly sandwiched between Joseph Cotten in *Shadow of a Doubt* and William Demarest in *My 3 Sons*.

One could not ask for a better edition of **STORM FEAR** than the one served up by Kino-Classics. The razor-clarity of the pristine 35mm transfer is one of the best I've ever seen from the company (and certainly the finest ever bestowed upon this title). The images are so precise that the depth is almost three-dimensional.

A quirky noir well-worth exploring, **STORM FEAR** lives up to its moniker. And then some.

STORM FEAR. *Black and white. Widescreen [1.85:1;1080p High Definition]. 2.0 DTS-HD MA. Kino-Lorber Studio Classics. CAT # K1750.*

DESPICABLE MEEKER

Remember the cliché/adage, "Throw a hundred knives up at the ceiling and one is bound to stick"? Well, when one replaces serrated eating utensils with cans of celluloid, and, when the thrower is none other than low-budget Bel-Air Productions, the answer invariably comes up **BIG HOUSE, U.S.A.**, a 1955 sordid noirish exercise, now on Blu-Ray from Kino-Lorber Studio Classics.

Bel-Air was the stomping ground for those fast-buck purveyors of the bottom-half co-features, Howard W. Koch and Aubrey Schenck. Their forays into schlock horror (the infamous albeit delightful *The Black Sleep*), rock 'n' roll (*Bop Girl Goes Calypso*), cut-rate oaters (*Revolt at Fort Laramie*)...well, you get the idea. Yet, at their company's embryonic stage, Koch and Schenck managed to corral some quality folk at the writing level to pen a suitable project for better-than-average Bel-Air contractees. Ergo, **BIG HOUSE, U.S.A.** – the moniker alone being a pseudo-homage to the pre-Code 1930 epic *The Big House*, which shot Wallace Beery to major stardom. Of course, to have a slob of Beery's

calibre is no mean feat; to their credit, Bel-Air strove to go one better and assembled a cast of **five** slobs, all of notable crotch-scratching gruntability. But we're getting ahead of ourselves.

The story for **BIG HOUSE, U.S.A.** came from the minds of two out of three Georges, namely George Slavin and George W. George. And it's a lulu! In fact, one wonders about the exploitative title, as the first act deceptively avoids any incarceration whatsoever. But that's how they lure you in (twirl mustache here).

In the beauteous pastoral Royal Gorge National Park in Colorado (actual location work, in and of itself a rarity for a contemporary Bel-Air epic) is a camp for rich liddle kiddies. One of them, the comely Danny Lambert (Peter J. Votrian), heir to millions, is on the sickly side, and, even though we envision him getting at least five military deferments in later life, we are sympathetic to his plight, especially when he is shabbily treated by the hottie nurse Euridice Evans (great names in this pic) who should definitely know better (and look, folks, it's Felicia Farr, billed as Randy Farr, in a nasty big-screen debut). So the tyke wanders

off and soon the entire county (if not country) is on the lookout for the sprout, who must get his meds or perish in a display of agonizing writhing that all thespians dream of.

Along comes Jerry Barker, a friendly fisherman/hiker, who recognizes the boy and gregariously offers to spirit him to safety...NOT. It's none other than Ralph Meeker, fresh from his stage triumphs as Stanley Kowalski, Hal from the original stage production of *Picnic* and a memorable MGM contract (here, at UA, he would not only emote for Bel-Air, but attain screen immortality the same year for his iconic portrayal of Mike Hammer in Robert Aldrich's classic *Kiss Me, Deadly*. Suffice to say, his role in this movie makes the sleazy Mickey Spillane detective look less Ralph Meeker and more Donald Meek). Smooth-talking predator Barker (not unlike the carnival kind) spirits the child to a dilapidated cabin, locks him in and proceeds to blackmail his worried father, Robertson Lambert (the terrific character actor Willis Bouchey) out of 200K. But the resourceful, tiny Lambert becomes seriously injured while attempting an escape, and Meeker, rather than perform CPR or hurry him to a proper

medical facility (he's already gotten his ransom), simply throws all caution to the wind – and by caution, we mean Danny – and flicks the unconscious body off a 1000-foot precipice of the Grand Canyon variety.

Apprehended, but with the money hidden and no body to be found, Barker smugly accepts his fate of a few years behind bars (suspicion of extortion being the only rap that sticks, sans *corpus delicti*), intent to wait it out and collect his booty (while other ancillary investigating lawmen Roy Roberts, Reed Hadley, Robert Bray and Stafford Repp do their level-best to uncover electric chair-worthy evidence)

And that's where **BIG HOUSE, U.S.A.** truly begins. Thrown into a cell with an unruly bunch of sociopaths, Meeker, christened by the press as The Iceman, comes up against a quartet of cons who aren't exactly thrilled to be roomies with an alleged child murderer. These unhygienic mugs and thugs comprise "Machine Gun" Mason (a grumpy, snarling William Talman), Alamo Smith (a grisly, grizzly Lon Chaney, Jr., out-Lennie-ing Lennie), Benny Kelly (a muscleman-obsessed

Charles Bronson), and, most prominently, Rollo Lamar (craggy Broderick Crawford, an intellectual maniac in the Wolf Larsen mold...and I do mean mold!). Crawford's a diamond in the rough, spelled "RUFF!" He makes witty asides that nobody but selected members of the audience gets (kudos to the acerbic script by John C. Higgins). When Meeker is announced as their newest tenant, Crawford greets him with "Oh, the iceman cometh." This bon mot is greeted with a foursome of head-shaking "Huh"s to which the *All the King's Men* Oscar-winner responds with an exasperated "Never mind, skip it" disclaimer.

Meeker gets it though, because he quickly realizes that Crawford's a bigger psycho than he is, and soon, a prerequisite crashout escape strategy takes hold. "I'm gonna kidnap a kidnapper for the money he kidnapped for" Rollo tells his co-conspirators about plans for the reluctant Meeker.

Just how big a psycho is Crawford? In *White Heat*, Jimmy Cagney snuffed Paul Guilfoyle, a repugnant snitch. In **BIG HOUSE, U.S.A.** Crawford boils buddy Bill McLean like a lobster merely for test-run laffs.

The climactic final third, with a beaten and deservedly abused Meeker led back to the scenic scene of the crime by his greedy tormenters, is a visual ordeal that even the most unsophisticated viewer will correctly surmise not ending well.

BIG HOUSE, U.S.A. is a surprisingly graphic, violent and sadistic little poison pill that keeps one suspensefully on-guard for most of its 83-minute duration. It's without question the best picture Bel-Air (or Koch, who directed) ever made. The stark black-and-white widescreen photography (which also features locations at Canon City, Colorado, Malibu Beach, California, Salt Lake City, Utah, the Gulf of Mexico and the Washington State McNeil Island Federal Penitentiary) by Gordon Avil (who did a number of Bel-Air pics, but is best-known as King Vidor's d.p. on *Hallelujah, Billy the Kid* and *The Champ*) looks great on the Kino Blu-Ray with the music by Paul Dunlap ominously appropriate.

Movies were certainly getting tougher in 1955 with this, the aforementioned *Kiss Me, Deadly, The Phenix City Story, House of Bamboo, The Man From Laramie* and others all vying for the

loudest "Oh, shit!" disbelief moment. That said, **BIG HOUSE, U.S.A.**, a picture where a happy-go-lucky child murderer **isn't** the most vile character, may just take those dubious jaw-dropping top honors.

BIG HOUSE, U.S.A. *Black and white. Widescreen [1.75:1; 1080p High Definition] 2.0 DTS-HD MA. Kino-Lorber Studio Classics/Metro-Goldwyn-Mayer Studios, Inc./20th Century-Fox Home Entertainment. CAT # K1748.*

SLIMEBALL'S CRIME BALL

A mobster into kinky sex, a gay hit team, an articulate socialite who likes "doing the nasty"(the nastier the better), and a self-loathing cop who falls for the dame in spite of her preference for bad boys. No, it's not the latest Tarantino epic, or a violent NR-17 Asian import. It's a movie from...wait for it...1955, a brilliant film noir classic entitled **THE BIG COMBO**, and it's available for the first time in a terrific Blu-Ray widescreen platter from Olive Films, in conjunction with UCLA

Film Archive, The Film Foundation and Ignite Films.

The movie has long been on an *enfant terrible* list for physical and narrative reasons. The latter is obvious from the opening statement; the former because of the god-awful copies flooding the home-vid market, due to the picture's original distributors, Allied Artists, negligently allowing it to fall into public domain. More on that later.

THE BIG COMBO is a gold-standard noir from frame one, its credentials beaming from in front of and behind the cameras. Helming the pic is the great Joseph H. Lewis, who wowed the genre's fans with his extraordinary 1950 masterpiece *Gun Crazy*. **COMBO** is every bit as good, and way dirtier. The script was written by Philip Yordan, the era's iconic "front," who only bearded for the best. The pic smacks of Abraham Polonsky, but who knows? Maybe Yordan actually did write some/all of it (he claims he *did* author many works). The structure is superb, the dialog blistering (and infinitely quotable) and the pacing non-stop: sensational writing at every level that dares to venture way beyond 1955 accepted

borders. The photography is by noir's most heralded painter, John Alton. The movie, long story short, looks fantastic, now more than ever. Finally, the score is by the wonderful David Raksin, whose jazzy music adds immensely to the medium-sized budget's production values (although certainly "A" list for Allied Artists).

Ultimately, for the masses, it's the cast that finally puts it over – custom-picked thesps sliding and slithering into their roles and film noir history.

THE BIG COMBO concerns the evil rise and reign of sadistic mobster "Mr. Brown" (Richard Conte in perhaps his finest role). Brown began as a brilliant accountant for gang leader Joe McClure (Brian Donlevy), a ruthless scumbag with ties to politics. Brains over brawn rules (as Brown soon discovers) and he quickly eclipses his employer (who now cowers beneath him, pathetically doing the psycho-sadist's bidding). By hiding accounts, currency laundering and dummy LLC holdings, Brown makes it hard to follow the money (which he knows is key to survival in post-War America); the only thing he hides better are the bodies (and there are plenty of them), specifically the

disappearance of his equally parasitic wife Alicia (Helen Walker). But aside from money and power, Brown has another jones: S&M and B&D (and they ain't railroads!). He's a sexual predator, who literally gets off by rough coital coupling (again, not trains) – a monster whose lust redefines the term "dangerous liaisons." Prime target is the beauteous Susan Lowell (Jean Wallace), a rich, well-read member of the elite with a love of art, music, good books and philanthropy. Susan's meeting with Brown causes an instant revulsion, not because who he is, but *what* he is. He brings out the worst in her, and, to quote the song, the girl can't help it. Susan becomes his willing love slave, unable to resist his brutal bedroom demands, no matter how low.

Trying to make sense of all of this is strait-laced detective Leonard Diamond (star-coproducer Cornel Wilde), who can't fathom Susan's attraction to Brown, especially since he craves her himself. This leads one of the movie's many magnificent good-evil confrontations, as a snickering Brown challenges by-the-book Diamond for Lowell's favors. Diamond only knows the law, so already Brown is in control, and

he smacks down the detective in a barrage of words that have had audiences screaming "Oh, SNAP!" for over sixty years. He ferociously outlines the differences between the two men, savagely explaining to the square-jawed dick why the female trophy will always choose boss over cop. It's not just the money, it's something far more addictive: "PER-SON-ALITY!" He sends a whipped (not so) Wilde running, simmering with revenge. Sadly, Conte (or, rather, his character) is (at least momentarily) correct in his assessment. Professionally speaking, Diamond wisely follows Brown's game plan, and methodically chases the trail of money and sex, leading to an eye-opening and genuinely shocking (dare we say?) climax.

When Brown *does* resort to violence, which becomes increasingly necessary, he employs his two faithful bodyguards/hitmen, a gay couple, Mingo and Fante (often pronounced "Fanny"), bizarrely believably portrayed by Earl Holliman and Lee Van Cleef. Mingo and Fante are thoroughly devoted to one another, and that's a good thing – 'cause they know their boss will throw them under the bus at a the drop of a gat.

As for the ineffectual former kingpin McClure, he (like Diamond) too harbors a molten grudge against Brown, and when it explodes, woo-boy! And explode it does, beginning with an attempt to win over Mingo and Fante. In a scathing exchange, he tells the boys, "I'm gonna show you two guys how to be MEN!"

Donlevy's character is one of noir's top villains *and* victims. He's afflicted with deafness, so must constantly adjust his hearing aid (used by Conte in one excruciating scene as a torture device). McClure's malady provides Lewis, Alton and the sound crew with one of the most innovative uses of audio-video in cinema, a startling nocturnal airport sequence that we won't further divulge. Suffice to say, it's the stuff noir dreams are made of.

Supporting the terrific aforementioned leads is one of the genre's strongest rosters of mugs and thugs ever. Weaving in and out of the flick's mean streets are Robert Middleton, Ted de Corsia, Jay Adler, Michael Mark, Whit Bissell, Philip Van Zandt and John Hoyt.

Surprisingly, **THE BIG COMBO** was released uncensored in 1955, proof that the Production Code was losing its bite. Or maybe they just didn't get what was really going on. Producer Wilde did. He wasn't too pleased with a sequence where his wife Wallace was obviously being serviced via cunilingus-hungry Conte. He protested to Lewis, imploring him to omit or soften the scene, but perhaps, in reference to Donlevy's character, it fell upon deaf ears. How very fortunate, as it's something of the likes not seen in American cinema since the days of pre-Code (it brings to mind the Frances Dee character in Rowland Brown's outstanding 1933 pip *Blood Money*).

The Olive Films Blu-Ray of **THE BIG COMBO** is one of the must-haves for any film noir library, for reasons as indicated above. After decades of inferior tapes and DVDs, it at last does John Alton the celluloid justice he and the pic deserve. Restored from 35MM elements, and for the first time in its original aspect ratio, this disc is a joy to behold. To paraphrase Mr. Brown, it's worth going down for.

THE BIG COMBO. *Black and white. Widescreen [1.78: 1; 1080p High Definition]; 1.0 DTS-HD MA. Olive Films/Ignite Films/UCLA Archive/The Film Foundation. CAT # OF714.*

BRIDE AND GLOOM

To be finally able to see the outstanding 1956 film noir shocker **A WOMAN'S DEVOTION** would be in and of itself a wonderful treat. To see the pic in such a stunning new 4K HD widescreen master (thanks to the groovy folks at Kino Lorber Studio Classics and Paramount Home Entertainment) is movie-lover nirvana.

To say that most movie fans of the noir genre have probably never heard of **A WOMAN'S DEVOTION** would likely be an understatement. Its rarity and obscurity seem to not only have become legend, but amazingly was aided and abetted by its studio, Republic Pictures, which made the Mexican-shot nightmarish thriller (more on that later).

First off, **A WOMAN'S DEVOTION** is one of those noir subgenres I love, the contradictory film noir

in color. To the purists and naysayers of color noir, I say "Piffle!" In my mind, those swirling, hypnotic picture-postcard visuals lend themselves to the WTF hopelessness that plague the key players in this and other rainbow pigmented noir entrees. Indeed, **A WOMAN'S DEVOTION** is like a FitzPatrick Travelogue, coproduced by Jack the Ripper, Ted Bundy and the Manson Family. It is expertly directed by Paul Henreid – yep, *that* Paul Henreid. Viktor Laszlo and Jerry Durrance, that romantic *Now Voyager* dude, who simultaneously lights two cigarettes for himself Bette Davis (who could probably smoke two cigarettes simultaneously). Truth be told, that aside from being a terrific thesp, Henreid was an excellent director, and one who was especially lured to dark places (he did over two dozen spine-tingling *Alfred Hitchcock Presents*). And places don't get much darker than **A WOMAN'S DEVOTION**.

Trevor and Stella Stevenson are a young, super-gorgeous honeymooning couple who descend upon a picturesque suburb of Acapulco. Trevor is finally enjoying the good life, after being through hell in Korea. Trauma couldn't have a better cure than spending it with the beautiful woman of your

dreams, and in a spectacular fantasy vacation spot like this lazy, sunny beach haven. But The Stevensons carry some baggage that can't be alleviated by porters. Stella is helping Trevor recover from a breakdown due to the severe mental anguish experienced while under fire. Prior to arriving in Mexico, he had blacked out and disappeared for varying periods of time. He seems to be getting better, but then the blackouts begin again. As do a series of murders.

Captain Henrique Monterors, a wily Maigret-esque police inspector with an eye for the ladies (third lead Henreid, wearing the second of many hats; again, more on that later), increasingly delves into his "beat's" newest tourists, and is alarmed at what he discovers (more unsolved murders). As all the loose ends become hangman's knot-tight, the story spider-web-weaves into a spine-tingling airstrip hangar climax. It isn't a satisfying one, veering toward gut-wrenching, but, hey, it's film noir, baby!

The story for **A WOMAN'S DEVOTION** particularly intrigued Henreid. It was one of the first scripts and movies (if not THE first) to deal

with PTSD. This makes **AWD** a landmark 1950s hunk of celluloid. The character of Trevor Stevenson isn't played as a monster (although he is occasionally frightening), but as a victim – a victim *with* victims. The casting couldn't be better. Stevenson is portrayed by Ralph Meeker, a year after his brilliant interpretation of Mike Hammer in Aldrich's *Kiss Me, Deadly*. The sympathetic, suspicious and strong supporting wife is perfectly enacted by Janice Rule. The chemistry between the two stars is undeniable. They really seem to be into each other, a masterful stroke of casting by Henreid (the pair had made Broadway history as Hal and Madge in the original production of *Picnic*). Henreid himself is coy, sophisticated and charming as an Austrian-accented Mexican official. His womanizing is contrasted by his devotion (a word that hits many notes in this freakish concerto of violence) to his daughter (he's a single parent). A nifty roster of supporting players include Jose Torvay as a creepy blackmailer, who may be on to Stevenson, and intends to milk this cash cow for all its parasitic juice, and, most startlingly Rosenda Monteros as a sensuous skank, working with Torvay. Monteros is an actress known for her

innocence (she's the village girl Horst Buchholz hooks up with in *The Magnificent Seven*). To see her as such an evil user is quite jaw-dropping.

The screenplay to **A WOMAN'S DEVOTION** is by Robert Hill. Henreid, himself, contributed to the writing, and while pleased with the final draft, was angered by what Republic did in post-production. They chopped out several sequences, which obviously wreaked havoc with the editorial flow and continuity of the narrative. To quote Henreid, "Apparently [Republic] didn't understand the film at all and cut essential parts." This is very noticeably evident when major characters vanish for long period of time (kinda like Meeker's blackouts). The resulting 88-minute duration is still unusual and worthy enough to warrant not only a peek, but a purchase.

What Republic did on top of their butchery was even worse. They changed the title of the movie, depending upon where the picture was exhibited and/or if it wasn't performing up to their expectations. Not once, but TWICE. At various times, it went out as **A WOMAN'S DEVOTION**, **BATTLE SHOCK**, and **ACAPULCO**. Audiences

weren't sure if this actually wasn't three movies made back-to-back or what. They played it safe, and stayed away from all of them.

Monika Henreid, the actor/director's daughter, recently shared some of her memories of the shooting of **A WOMAN'S DEVOTION** with me. "It was like a vacation for me. Not long ago I went through reels and reels of home movies we took while my father was filming the movie. He was extremely disappointed by what Republic did with it, as he had worked quite hard on the script, albeit uncredited. The title changes only made it worse.

"Republic was certainly a go-to studio for actors wanting to show their directing chops. The deal they made with my father, who had also directed some very successful movies, was that he could do it provided he also appeared in the picture. This was basically covering all the bases – a name in front of the camera could balance any problems that he/she might have behind the scenes. Of course, that wasn't the case with my father [or other star/directors; the studio made the same arrangement with Ray Milland, who did

a pair of great Republics, *A Man Alone* and *Lisbon* and Mark Stevens, who directed the fascinating noir *Cry Vengeance*]. Personally, I like the movie, but I don't *love* it. It certainly is a landmark motion picture, as it seriously and intelligently handles the subject of PTSD. My problem with the movie is the color. I'm old school. Film noir should be in black and white. For instance, I love Hitchcock, but am not a fan of *Vertigo* or those later pictures [grrrrrrr, Monika, *Vertigo* is my favorite movie of all-time!]. For me, it's *The 39 Steps, Notorious, Strangers on a Train...*

"That said, the movie *does* look beautiful and the acting is just fantastic. I should mention that both Janice Rule and Ralph Meeker were so nice to me, just great people. For years afterward, too. When I was pursuing an acting career in New York, Ralph was my protector. He offered sound advice on acting and the extracurricular activities that often go with it. I'd call Ralph, and tell him I was invited to so-and-so's...'Don't go,' he'd warn me. He was my surrogate father. Just a sweet man. I also remember going to Janice's home with my parents for parties and dinners, during the period when she was married to Ben Gazzara. So for me,

memories of **A WOMAN'S DEVOTION** are happy ones."

Monochrome purist or not, the Blu-Ray platter of **A WOMAN'S DEVOTION** should make Monika and all collectors even happier. It's one of those great, new 1080p High Def restorations of the faded, dull TrueColor elements that will floor you. The colors look like Technicolor at its best, absolutely popping out of the screen (and doing justice to d.p. Jorge Stahl, Jr.'s magnificent cinematography). There's no doubt in my mind that these Kino-Paramount-Republic restorations look better than they did in their original release. This could be one of their best. The mono audio is crisp, clear and features a score by Les Baxter. **NOTE:** while the Kino jacket indicates that the movie is presented in 2.35:1, **A WOMAN'S DEVOTION** is *not* a scope picture; the 1080p widescreen is in the proper, original aspect ratio of 1.85:1.

A suspenseful thriller worth rediscovering, **A WOMAN'S DEVOTION** will leave viewers startled and stranded in that OMG/WTF universe that only film noir can transport you to.

A WOMAN'S DEVOTION. *Color. Widescreen [1.85:1; 1080p High Definition]; 2.0 DTS-HD MA. Kino-Lorber Studio Classics/Paramount Home Entertainment. CAT # K22668.*

BLACK AND WHITE AND DEAD ALL OVER

Robert Wise is one of those A-list directors whose shining moments are emblazoned all over the pantheon of memorable cinema, but whose superb (and apparently) bottomless pit of little triumphs are never given the kudos they deserve. One of these, 1959's **ODDS AGAINST TOMORROW**, a brutal, uncompromising late noir, has just arrived on Blu-Ray from the folks at Olive Films/20th Century-Fox Home Entertainment/MGM Studios.

Now, admittedly, I'm tossing this vicious stunner into a bin including such obscurities as *Born to Kill, The Captive City, Destination: Gobi* and *Tribute to a Bad Man*. That's not entirely fair, as **ODDS AGAINST TOMORROW** has, as of late, slowly crept into the top echelon of the director's impressive filmography. The movie copped some major critical nods in 1959, but then more or less

quietly disappeared into late-night television oblivion. It definitely needs to be *totally* rediscovered.

On the surface, **ODDS AGAINST TOMORROW** is a textbook film noir heist picture. But, as the cast reveals, it's a far more complex vehicle covering (in unrelenting terms) some of the worst traits America has to offer.

The picture is about three losers. The first, David Burke (Ed Begley), a disgraced police official, recently released from jail ("Everybody was my friend until they needed a patsy"), has plotted a fool-proof robbery that will put him and two accomplices in money heaven for the rest of their lives (that's $50-$75 thousand per in 1959 economics). The next in line is Earle Slater, a virulent Southern racist, despising his having to live in Manhattan off Lorry, his successful wife. Slater's violent streak has caused him to go off the rails way too often. He's nearing the end of his road, and he knows it. This might be the vindication. His verbally abused clingy spouse, by the way, is Shelley Winters. Earle is the great Robert Ryan, complete with guttural drawl and a

sneer mean enough to keep any minority out of his reach. Earle is first introduced to us by strolling down Riverside Drive on a brisk autumn day. A group of children playing on the sidewalk gets in his way, and a small African-American girl bumps into him. Flashing a satanic grin with approximately 95 of his 32 teeth, Slater lifts her up and drools about what a lovely little pickaninny she is. It's the first of many goose-bump-raising moments.

None of this bodes well for the third member of the team, Johnny Ingram, a jazz musician with a serious gambling jones. Ingram is beautifully realized by Harry Belafonte (who shopped the project as his own independent production to UA, under the Habel moniker).

Johnny Ingram is the most complicated of the trio; he's a reasonable, sophisticated, well-read person who seemingly has had an eternal storm of bad luck. But look again; in his own quiet way, he's as racist as Slater, and almost immediately they clash with Burke serving as a reluctant referee ("I'll go down the drain on my own" he announces after his first meeting). Ingram is a

divorced father, still hopelessly in love with his upscale ex Ruth (the lovely Kim Hamilton) and young daughter Eadie (Lois Thorne). Outside of the gambling, one can't quite fathom why this couple broke up – until he arrives for his custody day with the child. Ruth is in the middle of a local school board meeting in their apartment, for which Ingram reverts to a bombardment of Auntie Thomasina, whitey kiss-up, and a traitor-to-their-people epithets. Johnny lectures her on their never getting ahead by bootlicking outside her race. Of course, it's all bosh. His breaking down gets a sympathetic caress from Ruth, who admits she still loves him. "Then why did we split?" asks Johnny. "Not for me, for her," indicating their daughter, a move Ingram accepts with anguish.

When the vile mobster Bacco (Will Kuluva) and his thugs threaten to harm Johnny's family unless he pay up his mounting debts, an enraged Ingram explodes, alas, now accepting that his only way out is to sign on with Burke and Slater. Slater, too, knows that he will never make it in Respectville unless he has the bucks to do it. Checking out the small upstate New York bank with the rogue top cop, a smirking Burke boasts

of the ease with which they can carry out the robbery. Perfect, isn't it? "Yeah, with one exception," reminds Earle, reprimanding his partner for not saying "nothing about the third man being a nigger."

Slater's self-loathing (a Ryan specialty) is tested when Lorry is called away to business conference; immediately, the womanizing bigot begins to paw and seduce the married upstairs neighbor. Of course, this isn't too difficult to grasp, as the woman is Gloria Grahame, wearing black lingerie under her bathrobe – and she's more than willing to take on Ryan. Wise directing Ryan and Grahame must have seemed like old home week at RKO; the pair's brief scenes together are terrific, with Ryan especially creepy and Grahame overly weary (when Earle's unnerved lover asks what it's like to really lose it, Slater soberly replies, "It scared me, but I enjoyed it."). For Earle, also a misogynist, it's just another revenge tactic on Lorry/women, who control/pity him. Johnny's disheartened participation in the caper is likewise because of the women in his life. Even Burke reveals his disdain for the opposite sex. When Slater asks him why he has a giant German

shepherd in a small Manhattan apartment, Burke replies it's because he "never got a wife." Once again, it's RKO *deja vu*, recalling these two magnificent actors' relationship in the brilliant Nick Ray noir *On Dangerous Ground*.

The finale erupts in violence perpetrated by escalating bigotry and remains one of noir's most visually snarky endings in the entire genre. That's all I'm going to say.

ODDS AGAINST TOMORROW is a 100% New York City progressive movie. All the key participants were liberals, in front of and behind the camera (Wise's wonderful use of Empire State locations proved an ideal run-through for his next UA/ NYC project, *West Side Story*. It was a busy time).

Belafonte aced the producer role with a vengeance, not only with his choice in costars and director, but in the script, camera and music departments as well. The screenplay, blistering with lines so tough and ahead of the curve that it's amazing they ended up in the final cut (when the gang punks threaten his family, Ingram vows

he'll hunt them down and "blow them a new one!") and probably only made it because the censors didn't get the full meaning. The movie was based upon a riveting William P. McGiven novel, and coscripted by Abraham Polonsky and Nelson Gidding. Since Polonsky had been blacklisted, he was fronted by John O. Killens. Like so many newly remastered 1950s American flicks, **ODDS AGAINST TOMORROW** now has replaced main titles (in the same fonts and graphics), with Killens's removed, and full co-credit given to Polonsky (part of a restoration of this title between the studio and the BFI). The stark black-and-white cinematography is by the versatile Joseph C. Brun, who had just come off *Windjammer*. Talk about opposite extremes. The music score is by Modern Jazz Quartet great John Lewis, and the picture features several numbers inside the club where Johnny is employed, one naturally performed by Belafonte, the other by the remarkable thesp/singer Mae Barnes. The remaining cast of New York hopefuls is another unbelievable coup, and features such familiar faces as Diana Sands, Barney Martin, Robert Earl Jones (James' pop), Wayne Rogers and Zohra

Lampert (in their big screen debuts), Allen Nourse and, as a ultra-cool bartender, Cicely Tyson.

Racism was really "in" for Hollywood in 1959. *No Way Out, The Phenix City Story, Edge of the City, Kings Go Forth* and *No Down Payment* had previously dealt with it. But it was 1958's *The Defiant Ones* that made the topic box-office friendly, so for UA (who had bankrolled *Defiant*) **ODDS** was a no-brainer.

The Olive Films Blu-ray is generally of excellent 35MM quality. There are a few cases of grain, but that may have been always the case. The movie was entirely shot in New York with interiors lensed at the Gold Medal Studios in The Bronx. The mono audio is fairly dynamic with slight, infrequent sibilants. This widescreen High-Definition edition is the best print I've ever seen on the title, and thus is highly recommended.

ODDS AGAINST TOMORROW. *Black and White. Widescreen [1.85:1; 1080p High Definition]; 2.0 DTS-HD MA. Olive Films/20th Century-Fox Home Entertainment/MGM Studios. CAT # OF1416. Region A.*

Homage a Sam

STACKED DECK

For hard-boiled journalist turned master filmmaker Sam Fuller, the *Chicago Manual of Style* has a double meaning. Sure, that tabloid in-your-gut stiletto-sharp prose hits its mark, but the city's history of gangland violence plays an equal part in the Fuller cinema legacy. And Tokyo (with a side excursion to Yokohama), Chicago Style never had a truer meaning than in the director-writer's magnificent 1955 contradictory (it's a color-noir) **HOUSE OF BAMBOO**, now on limited edition from the folks at Twilight Time/20th Century-Fox Home Entertainment.

I've always loved this movie, and, like so many of the great ones, it just seems to get better with each viewing. The story, as written by Harry Kleiner (with iconic Fuller additional dialog: "He sure knew how to die," "A strait-jacket would fit you just right."), concerns a band of dishonorably discharged American GIs stationed in Japan who form a criminal cartel that rivals Capone's Windy City mob. When their crime wave escalates to

knocking over a train carrying U.S. military munitions, the Army joins forces with the Japanese police to stop them. It's the how, why, where, what and when – you know, the newspaperman's mantra guideline – that unravels the twisty narrative's spidery cobweb of fear and deceit with sledgehammer tabloid fashion as the law enforcement factions plant a mole within the already paranoid gang's top echelon.

Evil, the movie's inside out moral tells us, is the root of all money – and, thus, its own undoing. The gang's motto is the tried and true "take no prisoners." Except they've freshened it up a bit; not only do they remove all pursuers, but, should one of their own go down, it's a bullet in the dead-men-tell-no-tales head. This is a non-negotiable edict issued and enforced by the group's corporate-minded psychopathic leader, Sandy, aka the wonderful Robert Ryan, one of the most memorable of Fuller's many favorite-monikered Sandys, (to say nothing of Griffs, and there's one of those too).

But their latest collateral damage sacrifice is clinging to life and semi-consciously reveals that

there's a secret woman who rocks his world, and that his best friend, Eddie Spanier (now doing time in the States), is due to join him upon his release. Eddie, a vicious thug, arrives and immediately begins horning in on Sandy's *pachinko* protection racket sideline. Spanier's raw propensity for blood and greed ingratiates him into Ryan's favor, who risks offering him a top spot in the mob. Of course, the real Eddie is under wraps in America; this Eddie is special agent Robert Stack, who infiltrates the malicious band as well as his dead "pal's" squeeze (actually the gunman's gorgeous Japanese wife), Mariko. And that's merely the beginning to this crazed, nightmarish descent into 1950s noirland.

There's so much to talk about when seriously discussing the complex **HOUSE OF BAMBOO**, but I'm savvy enough to realize that time and space is of the essence, so I'll stick to the basics. First off, the cast. Each selected actor and actress is letter perfect, although, ironically, Stack wasn't the first choice. Fuller insisted that the entire picture be shot on-location throughout the streets of Japan's largest cities via hidden cameras. Since the Fifties began, the indie star profit participation programs

(where tax incentives were contingent upon highly-paid talent spending a good deal of the year outside the United States), Fox (and other studios) heavily promoted exotic locales for their A-product. This was a win/win, as it also provided a scenic backdrop for the new widescreen processes. CinemaScope was as important a selling point as a Clark Gable or Cary Grant or Susan Hayward. Unquestionably, **HOUSE OF BAMBOO** was Fuller's most extravagant and elaborate project to date, and, originally, it was announced that Gary Cooper (already taking advantage of the expat tax perks, a la *Garden of Evil, Blowing Wild, Vera Cruz* and *Return to Paradise*) would be playing Eddie. Alas, test shots of the tall, gaunt actor strolling through the highways and byways of Tokyo aroused the American-movie-mad Japanese citizenry, who mobbed the star within seconds of the hidden cam's rolling. It was decided that Victor Mature would be a suitable replacement, but, he similarly, was too recognizable (*Samson and Delilah* and *The Robe* had been massive hits in Japan). Next up was Stack, who fit the bill handily (his international fame in *The Untouchables* being four years away, and *The High and the Mighty*

had yet to be released in the Far East territories). This boosted second lead Robert Ryan up to star billing. Ryan, of course, is terrific as usual – becoming a victim of his own mania. As Sandy, he disregards his own rules by rescuing a wounded Eddie. This doubly serves to explain his rabid treatment of Mariko, who has entered Stack's life; Sandy's misogyny and unusual *compadre* compassion is nothing less than his falling in love with Stack's character, similar to Richard Boone's attraction to Randolph Scott in Boetticher's *The Tall T*. Transcending the interracial romance, it daringly becomes **BAMBOO**'s cloaked taboo.

Then there's the beguiling casting of the sensuously beautiful Shirley Yamaguchi, whose bio is far more fascinating than any character she ever played: WWII Rising Sun propaganda cinema queen, accused Chinese double-agent traitor, celebrated singer (heralded as the Judy Garland of Japan), one-time wife of famed artist Isamu Noguchi, American movie star and, last (but definitely not least), Japanese right-wing pundit and politician. *Kuso haii, Shirl!* For the actress's scores of admirers, Yamaguchi's come-hither wet

look, as she alights from a communal bath wrapped only in a towel, remains a key poster graphic, indeed one of the most overtly sexual American movie promotional images of the 1950s. Eat your heart out, Ann Coulter (on the dubious premise that you have one).

The rest of Ryan's gang is certainly worth mentioning (Biff Elliott and Robert Quarry), but particularly DeForrest Kelley (slimily Iago-esque) and, in his Fox contract specialty of Hot Head Third Male Lead Who Always Gets Killed (*Pony Solider, Garden of Evil, The Tall Men, No Down Payment*), Cameron Mitchell. My fave person of interest in this rogue's gallery is the brief, yet potent appearance by Harry Carey, Jr., as Ryan's traveling weapons supplier, essentially a precursor to Steven Prince's role in *Taxi Driver*. Aside from fire power, he also delivers my favorite line in the picture. Proudly exhibiting his formidable stolen Army wares from a bulging satchel, a cynical Stack sneers, "You must know the ordinance sergeant." To which Dobe snarls back, "I AM the ordinance sergeant." Yes!

The "good guy" side ain't chopped liver either. In a rare positive role, Brad Dexter nails the honest (but kinda thick) military official, while Sessue Hayakawa (dubbed by actor Richard Loo), two years from making an American comeback (in *Bridge on the River Kwai*) from his silent screen leading man days, is believably calculating as the police Inspector Kito. And Fuller himself appears as a Japanese policeman!

As indicated earlier, the locations in CinemaScope comprised a major attraction of big-budgeted movies of the era, and **HOUSE OF BAMBOO** is no exception. In Fuller's gifted hands, the spectacular compositions are not merely rectangular-framed background wallpaper, but play an integral part of the scenario. Tokyo's teeming asphalt passages during a planned robbery's execution are breathtaking, but not as much as perhaps the most amazing, jaw-dropping location in any movie (certainly a noir) – a tense, suspenseful chase and shootout in a sprawling amusement park, built entirely atop the city's Matsuma department-store skyscraper. Of course the photography must be mentioned and the various set pieces are superbly staged by Fuller and the

great d.p. Joe MacDonald. The soundtrack, likewise, must be praised; I greatly admire the score by Leigh Harline, specifically the incredibly beauteous intimate theme that audibly captures the growing relationship between Stack and Yamaguchi.

I asked Sam's widow, actress/producer/writer Christa (Lang) Fuller, if she had any interesting background info on this movie, and, through an email, provided a couple of nuggets that I felt worthy of mentioning. Not surprisingly (as they were both adhered to the same political ideology), Fuller and Ryan bonded during the filming of **BAMBOO**. For years, they seriously discussed forming a production company, a dream that sadly ended when Ryan was diagnosed with terminal cancer. In a more humorous vein, Christa revealed an incident involving Stack. "Robert Stack almost got killed by [a] mob during the shooting, because Sam did not tell him that the crowd was not informed about a film being shot and [they] threw themselves on him when [paid extras began to shout] 'THIEF.' Stack forgave Sam though

because he met his lovely wife Rosemary through him..."

Christa also suggested that interested Fuller fans check out *A Fuller Life*, a marvelous personal yet comprehensive chronicle of the artist's career and achievements by their daughter Samantha (chrisamfilms.com). To say that I strongly second that suggestion is an understatement. The documentary is a quintessential companion piece to the director's fantastic autobiography *A Third Face: My Tale of Writing, Fighting and Filmmaking* (a volume recommended without reservation, and one that contains an entire chapter on **HOUSE OF BAMBOO**).

The Twilight Time Blu-ray of **HOUSE OF BAMBOO** is a stunner. If one had previously purchased the 2005 Fox DVD, they are probably saying, "Hey, this looked pretty good. Why switch?" True enough, but, like all excellent Blu-Rays, this master goes one better, more bang for your buck (and there are lots of bangs). The colors pop just a little bit more to make a difference, and are accentuated by the vastly clearer imagery (in 2.55:1, as opposed to the usual

CinemaScope 2.35, narrower to account for the original release's stereophonic mag track). The sound, re-mixed from the 1955 stereo elements, in 5.1 DTS-HD, is movie-theater dynamic (with Harline's aforementioned score available as an IST). To sweeten the pot, Twilight Time has not only included the DVD optional commentary by Alain Silver and James Ursini, but has added a new alternative audio supplement featuring Julie Kirgo and Nick Redman. There's also related Fox Movietone newsreels and the theatrical trailer. Remember, this is a limited edition, so, *noiristas*, when this is gone – it's *sayonara*. Go Sandy, my fellow movie addicts, and take no prisoners!

HOUSE OF BAMBOO. *Color. Widescreen [2.55:1; 1080p High Definition] 5.1 DTS-HD MA. Twilight Time/20th Century-Fox Home Entertainment. CAT # TWILIGHT165-BR.*

Limited Edition of 3000, available exclusively through Screen Archives Entertainment (www.screenarchives.com) and www.twilighttimemovies.com

SAM'S TWILIGHT PEOPLE

With the impact of a right *and* left cross, Twilight Time (in conjunction with Columbia Pictures Industries) proves itself to be the Blu-Ray heavyweight champ of the month with the release of Sam Fuller great shamefully underrated 1959 knockout **THE CRIMSON KIMONO**

Fuller's Columbia directorial debut, **THE CRIMSON KIMONO**, one of his two brilliant Gower Gulch exercises in late noir (the other being 1961's extraordinary *Underworld, U.S.A.)*, is an unbridled opus of sex, violence, love and passion that concurrently rips the hypocrisy mask off American race relations. It also is one of the first U.S. motion pictures to depict the use of martial arts.

On the surface, the movie is a startling thriller about the search for the psychopathic murderer of stripper Sugar Torch (Gloria Pall) in Los Angeles' Japanese quarter.

But the *real* story of **THE CRIMSON KIMONO** is a bromance between the detectives working the

case. Charlie Bancroft (Glenn Corbett, in his movie debut) is a decent straight-up guy with an obsession for doing the right thing. No one gets a free ride. His BFF, Japanese-American Joe Kojaku (James Shigeta) is also his savoir. They met during Korea, and their bond extended to Joe's agreeing to an emergency blood transfusion, saving Charlie's life. Thus, they are blood brothers in every sense of the word. Kojaku even follows Bancroft back to L.A. and joins the force. They're also roomies, pooling their salaries to have virtually nothing but their swank man-cave apartment.

This relationship is ideal until the Crimson Kimono case breaks. The aforementioned Sugar, trying to elevate the vocation of stripping, wrote and choreographed an artistic dance piece surrounding the title garment. It's basically *Madame Butterfly* with T & A. The artist she hired to create the exquisite posters is tracked down after the interpretive dancer's murder. Both Charlie and Joe are amazed and pleased to discover it's a woman, the masculine-named Chris Downs (top-billed Victoria Shaw).

Charlie falls hard for her, and she begins to feel likewise – until she meets Joe. You see, aside from being a class-A cop, Kojaku has the soul of an artist (he plays and composes music and is a scholar of ancient and contemporary culture; his father is a revered painter). Joe goes ga-ga in a big way, with his guilt being simultaneously unveiled, as his raging hormones kick in. The revealing of the dangerous triangle has the unexpected (and, thus, perfect Fuller) effect. In contrast, the sensational ads Columbia placed hit the interracial couple bit with notorious vengeance ("YES, this is a beautiful American girl in the arms of a Japanese boy!" screamed the one-sheets). It's Bancroft who understands, and, though hurt, is gratified that two great people in his life are together. Kojaku, on the other hand, reacts viciously, believing Charlie despises him for stealing his woman, but, more so for being the non-white dude who did the deed. Their mutual respect and affection quickly erodes into a vengeful and bigoted animosity (but, again, nearly totally emanating from Joe's damaged psyche of being a minority in America).

Their regeneration and healing makes up the crux of the final act that intertwines with resolving the tabloid-sensational case, culminating in a *cinema verite* chase (some in 16MM) through the authentic mean street locations in Little Tokyo during a Japanese celebratory event. The outstanding supporting cast includes Paul Dubov, Neyle Morrow, Jacqueline Greene, Walter Burke, Stafford Repp, and best of all, Anna Lee in possibly her greatest role ever, *avant-garde* artist Mac (interestingly, the role reversal ideas extend to the given names; pronunciation-wise, Charlie and Joe could be mistakenly taken as female monikers, while Chris and Mac would definitely be initially pegged as male characters; in fact, in Chris's case, it is).

From the director's blistering script to the stark monochrome photography of Sam Leavitt and the appropriately sleazy chic score by Harry Sukman (available as an IMT) Sam Fuller pics don't get much better than **THE CRIMSON KIMONO**, and one couldn't ask for a better rendition than in this spectacular Twilight Time widescreen Blu-Ray. Additional special extras include two documentaries: *Sam Fuller Storyteller* and *Curtis*

Hanson: The Culture of **The Crimson Kimono**, plus theatrical trailers.

Twilight Time has certainly done the maverick right; this is their third Fuller title on their label (the other being the quintessential 1955 color noir *House of Bamboo* (covered in the previous entry).

These are all limited edition Blu-Rays, and there is no doubt in my mind that they will be scooped up in record time, so youse Sam/noir addicts better get cracking!

THE CRIMSON KIMONO. *Black and white. Widescreen [1.85:1; 1080p High Definition]; 1.0 DTS-HD MA. Twilight Time/Columbia Pictures Industries. CAT #: TWILIGHT285-BR.*

Limited edition of 3000; available exclusively through Screen Archives Entertainment (www.screenarchives.com) and Twilight Time Movies (www.twilighttimemovies.com).

EDGY CLIFF

Perhaps the most visceral, ferocious entry in writer/director Samuel Fuller's canon (and that's saying plenty!), the sensational 1961 film noir **UNDERWORLD U.S.A.** blasts its way on to a limited edition Blu-Ray, thanks to the folks at Twilight Time/Columbia Pictures Industries.

The movie is a non-stop treatise on abuse and violent revenge, spanning a quarter of a century and, thus, becomes a social commentary on the decline and corruption of America from pre-to-post WWII. Of course, Sam is way too clever and inventive to deliver a much-needed message to movie audiences, so this warning is delivered in a brilliantly constructed, rousing entertainment package.

Tolly Devlin, first seen as a child in 1939, is a victim of a nasty one-two punch. Raised by a hoodlum single parent, the boy witnesses his father's brutal murder at the hands of greedy neighborhood thugs. Realizing that he has to live off the streets to survive, Tolly gets the Junior Mints version of his dad's fate when teens rob him

of his ill-gotten gains and cap their score by scarring his face with a switchblade. Devlin's only lifeline to sanity is Sandy, his surrogate mother – a sassy Texas Guinan saloon owner who tries her best to look out for the urchin. Nevertheless Devin spends the majority of World War II in a juvie lockup, and, when finally released, like all smart young hoods, comes out more fucked-up than ever (it should be noted that 1939 is also the year of Raoul Walsh's *The Roaring Twenties*, a movie this pic pays humble homage to *a la* the Tolly/Sandy relationship).

Devlin is now a take-no-prisoners alpha male – ready to squeeze the already rigged system but not without first extracting vengeance on his father's killers (a cancer that has been festering in the back of his unstable mind for years). That the men responsible are all now well-connected criminal politicos and mob leaders controlling a nationwide cartel of drugs, whores and money laundering makes Devlin's plan all the more difficult. And dangerous.

But Tolly's smart; if, in *Sweet Smell of Success*, the Tony Curtis character was "a cookie filled with

arsenic," Devlin's a stale loaf of bread laced with strychnine and chards of broken glass. Thus, the savvy hood stealthily assimilates into the modern mafia and, like all Grade-A scum, rises to the top. Then the powder keg blows.

UNDERWORLD U.S.A. was the director's last pic to get a major American distributor. It remains quintessential Fuller, first-rate late noir and a template for low-budget movie making at its best. The dialog is biting, often as sharp as the knives utilized in the movie. The pic likewise appends its scripted words with visual puns, occasionally brutal, but snarkily funny. When a supposed stoolie rival is incinerated in a car bomb inferno, there's a cut to the smiling capo responsible, sitting in his car and lovingly fondling a smoke. "Gimme a light!," he commands as the background is illuminated by the flames and sounds of blazing carnage. A less subtle moment comes after another aftermath of violence when the camera languishes on the gutter and a trash can labeled "Keep Your City Clean."

Besides Sandy, the only other respectable character in the piece is Cuddles, a beautiful,

battered whore Tolly saves and begins a relationship with. Like Sandy, Cuddles sees enough decency in Devlin to devote herself to him, hoping he'll reform. That the only admirable people in **UNDERWORLD** are women (and both victims themselves), who rise above their situations and fight back reveals the feminist side of Fuller – and one that will surface more defined in his magnificent *The Naked Kiss,* three years later (but previously on view in *Hell and High Water, Forty Guns, China Gate* and *The Crimson Kimono*). Like *Kiss,* **UNDERWORLD** not only champions the female of the species, but takes up the plight of abused the children and the terrifying repercussions.

The fact of the matter is that Tolly Devlin would be a totally reprehensible POS if he wasn't played by a gifted actor who could manage to instill some compassion into his sardonic life force of vitriol. Fortunately Fuller was lucky enough to obtain the services of Cliff Robertson, who makes Devlin one of his greatest screen incarnations.

The supporting cast, too, is wonderful. As the Gladys George-esque "mom," Sandy, veteran

Beatrice Kay excels, as does Dolores Dorn as Cuddles. The remaining dregs of thugs and mobsters are ably impersonated by such formidable presences as Robert Emhardt, Paul Dubov, Richard Rust, and Peter Brocco.

The stark, blistering monochrome photography plays a key role in making this gangland epic the success it is; kudos to d.p. Hal Mohr. A pulpish score by Harry Sukman also delivers da goods (like all Twilight Time titles, the music is accessible as an IST).

The Twilight Time Blu-Ray is gorgeous, culled from near pristine 35MM black-and-white elements, and crystal-clear in 1080p High Definition splendor. It's obvious that this movie influenced an army of future directors and writers, and many will quickly see moments that conveniently snuck their way into subsequent flicks like *Goodfellas* and *Casino*. No surprise that this disc contains an intro by Martin Scorsese. There's also a brief documentary, *Sam Fuller, Storyteller*, plus the terrific original 1961 trailer, featuring Fuller himself. Remember, folks, this is a limited edition of 3000, so when they're gone – they be gone!

I won't say whether good triumphs over evil, as this is a Fuller movie, and in Sam's universe, there are no foregone conclusions. The great thing about a Sam Fuller movie is that even AFTER you've seen it, you're still not sure.

UNDERWORLD U.S.A. *Black and white. Widescreen [1.85:1; 1080p High Definition]; 1.0 DTS-HD MA. Twilight Time/Columbia Pictures Industries. CAT # TWILIGHT 324-BR.* SRP: $29.95.

Limited Edition of 3000. Available exclusively through Screen Archives Entertainment www.screenarchives.com and www.twilighttimemovies.com

PIGEON'S BIRDS OF PREY

How refreshing that the 1970s proved that those old masters of the hard-boiled flicks hadn't slowed down a bit. That their extension of a genre they virtually defined – now christened "neo-noir" – was alive and well and splattering thugs, dames and pushovers all over that R-rated asphalt. Indeed, even today, I still relish revisiting late works of Don Siegel (*Dirty Harry*), Robert Aldrich (*Hustle*), Phil Karlson (*Framed*), and now, thanks to Olive Films/Bavaria Atelier GmbH (in association with CHRISAM Films) the long-awaited return of Sam Fuller's marvelous 1972 wink at his malevolent cinematic past, the deliriously crazed **DEAD PIGEON ON BEETHOVEN STREET**.

It's been years since Olive first taunted us Fullerites with news that this bizarre masterpiece was headed for American Blu-Ray (at least since 2010), but, *noiristas* can exhale – at last, it's here, and well worth the wait. Not only is Sam's semi-spoof restored to the director's intended 127-minute running time (longer than the version I originally saw), but there's a fascinating feature-length documentary by Robert Fischer (**Return to**

Beethoven Street: Sam Fuller in Germany**)** that would be worth purchasing on its own.

DEAD PIGEON's narrative is about as funky as "out there" cinema can get; in fact, the plot is downright kooky. An American detective in Germany has been paid to infiltrate a gang of blackmailers who use beautiful women to seduce politicians. The sleuth is portrayed by Glenn Corbett), yet another of the director's "Sandy"s. Sandy's client is the favored U.S. candidate for president whose right wing opponents are out to get the politico 'cause he's "a goddamn socialist." Uh-oh.

The gang is a sophisticated operation run by Mensur, a smooth, suave Mabuse-esque fencing master (the great Anton Diffring, acknowledged in the documentary to be the best thesp in the pic, which is saying a lot in a cast that also includes Sieghardt Rupp, Alexander D'Arcy and, in a breathtaking cameo, Stephane Audran). Mensur's style reflects Mabuse's in so many ways, specifically his obsessive high-tech (for the 1970s) methods of tracking, stalking and invading his intended victim's privacy (he also utilizes video

conferencing via large flat screens in his posh office). But there's another Lang connection, a namesake one – his *nummer eins* girl and ultimate *femme fatale*, Christa Lang (Fuller's real-life wife and the most dangerous delectable human *strudel* since Josef von Sternberg unleashed Marlene Dietrich's X-27 in *Dishonored*; toss in Lola Lola and Shanghai Lily by way of the Manson family and you've got a pretty good idea of the trouble awaiting any dumb-ass male).

Christa, whose name in the movie is also Christa, is immediately dispatched to "meet cute" with Sandy, who is doing the same from his end. Their finesse at treachery and penchant for violence at once ignites a spark of genuine attraction. Of course, neither can trust each other, and each does have a job to do. And so it goes.

The movie's history, originally conceived as an episode for *Tatort*, a long-running German crime series (quite possibly the world's longest running TV show, still broadcasting after nearly fifty years), is a primer of filmmaking deception in and of itself. Sam, as Fischer's doc reveals, was unable to secure funding for the kind of projects he wanted

in the States, and began talks with the producers of the famed Deutsche Fernsehsendung. Once agreed, Fuller relegated Kressin, the show's lead character (Rupp), to a minor background supporting player, moved in Corbett and basically made a bogus installment of *Tatort*, but a 100% authentic Sam Fuller picture (the producers, interviewed by Fischer, laugh it off at how they were so seamlessly bamboozled, not knowing what to make of Sam's English-language final cut).

The parallels between Diffring's organization and Rupp's agency are striking, as are the tactics used by Christa and Sandy. The latter even hires a sleazy sometimes pornographer (actor/director/film historian Hans C. Blumenberg) to help frame dupes by placing their heads on incriminating hooker action candids (in essence the 1972 version of Photoshop, another nod to technology, albeit not as refined as Diffring's). There's a wonderful dual sequence of Christa/Corbett complaining about their plight with one another to Diffring/Rupp (essentially whining "bastard"/ "bitch" to their uninterested, but amused, superiors).

Of course, there are some trademark Fuller set pieces, including a chase and shootout in a maternity ward (featuring Diffring's key assassin, a ruthless psychopath with comical moniker of Charlie Umlaut, played with panache by (Eric P. Caspar). This unorthodox gunplay is Sam's idea of being wacky, culminating with Fuller paying homage to himself when Umlaut gets chin-bumped down a flight of stairs, *a la* Richard Kiley in *Pickup on South Street*.

The dialog, too, is often inspired – with Christa getting the best lines (to verbally accentuate her curves). As Corbett attempts to be gentlemanly with the seductress, she suspiciously (and beautifully) delivers a killer *bon mot* response: "The last time a man held a door open for me, we were going 60 miles per hour!" When the pair finally succumbs to what Cole Porter famously pegged as the "urge to merge," Corbett ponders if this is at last the real thing. Christa heads him off at the pass: "Everybody likes everybody when they kiss," she snarkily replies.

DEAD PIGEON ON BEETHOVEN STREET also answers an age-old movie question that has

bothered me ever since I saw my first Bijou duel. When someone loses their blade, why don't they go hog wild and do a kitchen sink retaliation at their opponent? Corbett gets to do just that in an epic fight with Diffring, with startling and satisfying results.

I first saw **DEAD PIGEON ON BEETHOVEN STREET** at a special screening in 1973 at Fabiano Canosa's legendary First Avenue Screening Room. The great late writer/director Ric Menello and I couldn't wait to get there and were appropriately dazzled by the results, even though the version we saw was around 100 minutes, nearly a half-hour shorter than the Olive Blu-Ray. For more than forty years, two sequences remained embedded in my admittedly demented mind: a scene where Corbett follows Christa into a cinema showing a revival of Hawks' *Rio Bravo* (with the Duke joyously dubbed in German), and a mountaintop castle picnic between Christa and Corbett. Proud to say that both these segments hold up AND are integral to the scenario. In the movie theater episode, Corbett is so jubilantly enthralled by seeing Wayne that he almost loses sight of the reason he came (and nearly loses

Christa, who ducks out). In the second bit, the picnic/romantic date, Corbett clumsily attempts to woo Christa with some "sweet nothings" love talk; while many a man would talk of his would-be conquest's soft skin, limpid peepers, tempting lips, Corbett instead offers how much he admires "the little circles under your eyes." Christa smashes his coy charm with a loud and happy "They're BAGS!" Shelley couldn't have written it better (and I mean Shelley Winters).

The sumptuous locations of **DEAD PIGEON**, of course, are part of the movie's plot (and include a climactic festival and, naturally, some action on the title's mean *strasse*. The lush photography by Jerzy Lipman (with some 16MM handheld inserts by Fuller) looks swell on this meticulously restored Blu-Ray. The audio occasionally comes off as slightly muffled, but it's in no way annoying or irritating enough to harm the enjoyment of this freewheeling excursion into movie lunacy (beginning with the daft credits, where cast and crew members appear in mostly clownish attire).

I spoke briefly with Christa Fuller over the phone, and she, as usual, served up some enticing

ancillary tidbits about the pic. "Jerzy Lipman, the d.p., was told in no uncertain terms by Roman Polanski [Lipman was the cinematographer on Polanski's *Knife in the Water*] to ask no questions and to do whatever Sam Fuller says." When I inquired as to any personal memories of the shoot, she replied, "I remember it was so bitterly cold during the filming, but it was a totally pleasant experience. Sam, you know, adored the New Wave, and **DEAD PIGEON ON BEETHOVEN STREET**, I believe, was his affectionate wink to that movement and to the filmmakers. By the way, I think I'm very funny in the film, don't you?" Hell, yeah, Christa!

As indicated, the documentary is quintessential viewing, offering not only a comprehensive look regarding **DEAD PIGEON**'s pre-production, shooting, post-production fate and resurrection, but also serving as an authoritative visual guide on Sam Fuller and his overall career. With clips, sidebar interviews (including Lang, Caspar, Blumenberg and Wim Wenders), on-location home movies, and even music by CAN (the rock band who composed **DEAD PIGEON**'s original score) *Return to Beethoven Street* is an

exhaustive, thoroughly entertaining and frequently rollicking ride with one of motion picture's true mavericks (ideally complemented by Samantha Fuller's superb feature-length work on her father, *A Fuller Life*, available at http://chrisamfilms.com/). Simply put, Olive Films' **DEAD PIGEON ON BEETHOVEN STREET** is one of the best Blu-Rays of the year.

Oh, and as for Christa and Corbett, hey – it's a Sam Fuller movie, fill in the blanks (except, Spoiler Alert, they rarely use blanks).

DEAD PIGEON ON BEETHOVEN STREET. *Color. Full frame [1.33:1; 1080p High Definition]. 2.0 DTS-HD MA. Olive Films/ Bavaria Atelier GmbH (in association with CHRISAM Films). CAT # OF1189.*

DESIGN FOR SKEEVING

A *holy crap!* little noir from 1960, Leslie Stevens' gritty **PRIVATE PROPERTY** takes up residence on home vid via a stunning Blu-Ray (and DVD) from the gang at Cinelicious Pics.

Visually defining what inventive indie pictures are all about, **PRIVATE PROPERTY** chronicles the adventures of Duke and Boots, the Marquis de Sade's hip-talking version of George and Lennie (Corey Allen, Warren Oates) as they lie, cheat and steal their way across Camelot-era America. Duke is the knowledgeable, possibly even near-genius IQ dude who seems to have a fix on everything. Boots is his lackey, who, admittedly is still a virgin and craves sex – no matter how he (dare I say) comes about it. Duke offers to get it for him ("How do you want her, dead or alive?"), and a suitable victim seems to appear out of nowhere. The woman in question, Ann, a ravishing blonde (the beauteous Kate Manx) in a super car, drives by and immediately piques the two psychopaths' attention. Threatening a closeted racist (the great

Jerome Cowan) to follow the woman/chauffeur them to her dwelling proves to be a too-good-to-be-true situation for Satan's Hardy Boys. She lives in an upper-middle class suburban community; Roger, her successful money-obsessed husband (Robert Ward) is rarely present, and the classy house next door is up for sale and vacant. So Uday and Qusay "move in" on the crib – and then on the lady. Another perk, Mrs. Moneybags is horny, neglected, preens around the pool in suggestive outfits, tries her best to seduce hubby when he's around and is rife with enough inferiority complexes to fill the fall issue of *Psychology Today*.

Using (to quote Grace Kelly's Lisa Fremont) "rear window ethics," Duke and Boots spy on Ann with voyeuristic drool, all the while planning their "attack." The strategic upshot of these maneuvers comprises Duke "innocently" wandering on her property in the guise of a gardener, offering free consultation because the posies are so in need (and by posies, he ain't referring wholly to the flora). Allen convinces Manx, who allows him entrance (the worst thing you can do to a vampire), and voila! - the game is afoot. While

steadfastly loyal to her spouse, the lonely woman can't deny that the spirit is willing, but the flesh is weak...and pulsating. Ann's taboo sex fantasizing erupts in a masturbatory rite wherein the stunning woman slowly rubs a large candle up and down. Soon Duke is diving into her pool, donned only in jeans, and Ann spends the nights in bed caressing his conveniently forgotten leather belt, which she erotically winds around her neck. Boots, meanwhile, stuck in the deserted manse, begins to get jealous, knowing too well that his slick alpha bud has decided to keep the prize in question for himself. Allen viciously responds to his dense pal by tossing some eyebrow-raising gay slurs at Oates that are met with teeth-gnashing anger (but not denial). And when jealously, sexual tension, greed and adultery all bite into forbidden fruit – it's mushroom cloud time in Levittown. The horrific climax, with spouse Roger finally arriving ahead of the cavalry, figuratively severs the cool head of maniac Duke, who, in fit of violent rage (with Boots surprisingly rational, in a lunatic sort of way), goes all Cody Jarret on the group while Ann and Rog vigorously defend their respective...private property (real estate-wise and human).

This movie is a pip, a 79-minute powder keg of human emotion, a true rediscovery (obviously, it got little play in 1960 America). Stevens, of course, is best-known for being one of the creators of TV's *Outer Limits*, but this former protégé of Orson Welles first gained recognition with his comedy version of **PRIVATE**'s basic plotline, a theatrical piece entitled *The Marriage-Go-Round*, which told of a similar tale with the male of the household being the reward package; it was a smash on Broadway (and a lousy movie), making a star of the predatory lead female character, Julie Newmar. Manx, it should be noted, bears a resemblance to Newmar, but in a fragile, vulnerable way (this wasn't merely acting; the talented thesp took her own life four years later at the age of 34; at the time of **PRIVATE PROPERTY**, she was Stevens' wife). Stevens also penned another sex-outside-marriage piece, a terrific medieval play called *The Lovers*, which ended up as a flawed 1965 movie, *The War Lord* (all the pagan rite/supernatural stuff was cut out before the release).

The sex in the suburbs plot in post-*Peyton Place*, USA became a kind of mini-genre. In 1960 alone, two other movies tackled a similar, simmering

premise, Richard Quine's excellent *Strangers When We Meet* and the arguably sleazy, but engrossing, *Mantrap*, the second feature directed by Edmond O'Brien (which contained barbecue get-togethers/wife-swapping subplots – to say nothing of Stella Stevens. And one should *never* say nothing of Stella Stevens!). **PRIVATE**'s still photographer/visual consultant Alexander Singer himself helmed a *verboten*-lust epic in 1961, entitled *A Cold Wind in August*, starring Lola Albright as an available older woman. And then there's always *Look in Any Window* (also 1961) allowing demented teen peeping tom Paul Anka, to pant and sweat with wayyyy-too-much realism (thus adding an unnerving layer to the title *My Way*).

PRIVATE PROPERTY may be the masterpiece of the bunch, if not for the writing and acting then for the photography – spectacular monochrome imagery by the brilliant Ted McCord (*Treasure of the Sierra Madre, Johnny Belinda, The Breaking Point*); and if that wasn't enough, the camera operator was Conrad Hall. It don't get much better, folks.

Indeed, Stevens' later *Outer Limits* partner was no less than Joseph Stefano, scriptwriter for 1960's most successful shocker, *Psycho*. Aside from the aforementioned *Rear Window* nod, a wink-wink in-joke surfaces when Duke first approaches Ann ("I'm looking for the Hitchcock residence").

But let's talk about the acting. We've already briefly discussed Manx, and she's outstanding, but this is also Corey Allen's finest moment in front of the camera (he later turned director, mostly in TV); Allen is instantly recognizable to cineastes as Buzz, James Dean's doomed adversary in Nick Ray's *Rebel Without a Cause*. For Oates, it was an auspicious beginning to a magnificent early roll of roles; earlier in '60 he excelled as Ray Danton's kid brother in Budd Boetticher's *The Rise and Fall of Legs Diamond*, then, after a slew of memorable TV appearances, it was off to Sam Peckinpah's *Ride the High Country* (as one of the degenerate Hammond clan). The rest, as they say, is history.

The Cinelicious Pics Blu-Ray of **PRIVATE PROPERTY** does Stevens, McCord and Hall justice; it's amazing looking, perfect, tight widescreen compositions luxuriously displayed

with crystal-clarity and immaculate detail (the movie was thought lost until it was unearthed a couple of years ago by the UCLA Film and Television Archive, where it received this meticulous 4K High Definition restoration).

If you're a noir fan, with a penchant for the edgy-bordering-on-kinky, you might want to invite these types (incompatible and impossible variations of "snakes and birds," to quote Cowan's smarmy character) onto *your* private property, safe in the guarantee that they'll be there for less than an hour and a half.

PRIVATE PROPERTY. *Black and white. Widescreen (1.66:1; 1080p High Definition); DTS-HD MA. Cinelicious Pics. CAT # Cinelicious5. Two-disc set also includes High Definition DVD edition.*

NICE 'N' SLEAZY (DOES IT ALL THE TIME)

A rare Twilight Time Limited Edition double feature (in conjunction with Twentieth Century-Fox Home Entertainment) is available for one's viewing pleasure, via the video nasties 1960s twofer of Frank Sinatra neo-noirs **TONY ROME** (1967) and **LADY IN CEMENT** (1968).

Based on the Marvin H. Albert pulps (and scripted by Richard Breen and then Jack Guss, with assist from Albert himself), these tawdry, sun-drenched, Florida-based gumshoe shows unfold against a changing America, whose protagonist is an aging, semi-anachronistic private eye coming to terms with shifting mores while specifically embracing the sexual revolution.

Tony Rome (aka Frankie Sinatra) is a former Miami police detective turned indie shamus, with an allegiance leaning more toward the underworld's lovable cast of characters than to Establishment law and order. That his closest pal is a top lieutenant muckety-muck (the wonderful Richard Conte) gives the weary, snarky bedroom dick an edge – although sometimes straining the limits of

friendship (Rome gets chastised for leaving the precinct telephone number on his bookies' contact sheets).

While Tony is old school, he does attempt to culturally bring himself up to date with the new kind of violence (with relish), the burgeoning gay community (with vinegar), and the preponderance of free love (with honey), but is savvy enough to know that flashy, glitzy 1960s Florida crime is fueled by classic bloodletting. But, still, it's a tough pill to swallow; after all, Rome wasn't built in a day.

As Dean Martin once famously said, "It's Frank's world, we only live in it." This brilliant assessment of post-*Camelot* America is underlined by Tony Rome's universe – a place where *Playboy* 20-something hotties can't wait to get it on with a nearly 55-ish crumpled sleuth. It's a cinematic haven where the human background comprises Frank's real-life cohorts, buddies, hangers-on, etc. (some, admittedly, quite delightful: Hank Henry, Steve Peck, Joe E. Ross, Joe E. Lewis, Joe E. ANYBODY, B.S. Pully, Jilly Rizzo, Shecky Greene, Michael Romanoff and punch-drunk Rocky

Graziano as essentially, well, punch-drunk Rocky Graziano). The movies were slickly directed by Gordon Douglas, a veteran known for his quicksilver shooting (even though it's likely Frank was calling some of the shots). It was far enough away geographically from Fox and Hollywood for Sinatra to pretty much wreak havoc upon the denizens and traditions of the Sunshine State. A vacation outing (with pay), if ever there was one.

Frank, as it's well known, was great movie fan, and both these thrillers are packed with supporting actors from the Golden Age, an era where Bijou-addicted Sinatra was just coming into his own. Thus, it's a joy to see such wrinkled faces as Robert J. Wilke, Jeffrey Lynn, Lloyd Gough. And of course, there are the women. Pin-up pulchritude come to life, in the shapely forms of Sue Lyon (an unfairly maligned *Lolita*), the great Gena Rowlands, Jill St. John, Raquel Welch, Lainie Kazan, Deanna Lund, Tiffany Bolling, Joan Shalwee, Lynn Dano...the beat goes on.

True, the bikini-clad St. John in the first installment is "the" Frank fantasy: a beauteous, rich bimbo who covets him; in the second, she is

replaced by Welch, in virtually the same role and, likely, the same bikini. Frank's reaction to initially meeting St. John on a beach is trademark Italian urban smart-assery: "Oh, yeah, you gonna be my next case." Of course, it's a female turn-on.

The movies themselves show the underbelly of one of our country's highest rated winter getaways and retirement communities. It's rife with murderous hookers, drug dealers, pimps, psychos, illegally practicing doctors, corrupt detectives and more. They are shot in appropriately garish DeLuxe Color and 2.35:1 Panavision (Fox having only recently abandoned their CinemaScope process). The pics were exquisitely shot on-location by Joe Biroc (both movies, served on one 1080p platter, look terrif). The music, too, is key to the appreciation of the onscreen narrative; not surprising, considering its star. **TONY ROME** is scored by Johnny Mandell. The jewel of this lounge-music crown is the title song, belted out by no less than the star's daughter Nancy Sinatra (and penned by her mate Lee Hazelwood). It's a masterpiece. While I and my fellow Boomers weren't allowed to see these movies when released, for some reason, we were

all familiar with the title tune. I clearly remember that often, during the summers of '67 and '68, whenever an adolescent decision was circumspect, the unanimous response was "Tony Rome'll get cha if ya don't watch out!" Indeed, if Nancy's boots were made for walking, **TONY ROME** added some kickass cleats. The music in **LADY IN CEMENT**, sans a vocal, is nevertheless superior to its predecessor. The score, by Hugo Montenegro, is one of my favorite 1960s soundtracks, one I searched for decades to find on vinyl and/or CD (to no avail). Thanks to Twilight Time, I can now access this quintessential sly, naughty Bob Crewe-esque, Herb Alpert parody as an IST, where it is played often. Wah-wah-wah.

The plots are nearly interchangeable, but certainly in need of a mention. In his debut, Tony is ostensibly hired to retrieve jewelry, lost by a doped-up heiress (Lyon) found in a fleabag hotel. The sleazy house dick (Robert J. Wilke) is none other than Rome's former partner, pretty much the same relationship Robert Mitchum had with Steve Brodie in *Out of the Past*. Wilke ends up the same way as Brodie, too. The whole jewelry

deal is merely a pretense for what is to follow; soon, enough additional bodies to turn up to start a private morgue. As Rome correctly figures, the rich are always the dirtiest. This holds true for the sequel, featuring a former mob kingpin (Martin Gabel) in a concurrently menacing/hilarious performance) determined to become a legitimate businessman. The Barbara Nichols-type title corpse found at the bottom of the ocean ("She's one blonde I know didn't have more fun," cracks Tony) holds a key to a conspiracy involving mucho greenbacks and a slew of unsavory deals and folks.

Both pics owe an unpayable debt to classic film noir (**CEMENT** even has a Moose Malloy character, ably played by Rat Pack fave Dan Blocker). More importantly, Tony mouths a lingo of pure Hammett/Chandler speak, with 1960s codicils. Tony may have been the coolest peeper post-WWII and through the 1950s, but, by the late 1960s, he was losing his grip on the rapidly evolving culture. This isn't too different from what Sinatra himself was experiencing, desperately trying to keep ahead of the lingo curve, with sad results; remember his special,

Francis Albert Sinatra Does His Thing? Even *Rat Pack Confidential* author/fan Shawn Levy was forced to honestly comment on Ol' Blue Eyes donning a Nehru Jacket in the early 1970s ("He looked like an idiot"). Yet, there's enough iconic noir in the Rome flicks to warrant admiration for the aging gumshoe. "Do you really care?" asks a jaded mouse, suspicious of Rome's motives. "Sometimes I do," replies a solemn Tony, in a beautifully acted response that reminds us of how good a thespian Sinatra was.

Rome's phone calls with unseen bookies, fixers, and various other nefarious characters virtually constitute a string of amusing running gags. ("A pox on that horse!" shouts Rome, slamming down the receiver. "I'm working for free again this week!"). The lechery, so much a part of Rat Packery, is also on display. The leer Rome initially gives Raquel Welch in **CEMENT** gives the actress her best line, "Shall I scream 'rape' now?"

LADY IN CEMENT was every bit as successful as **TONY ROME**, and had fans of the possible franchise wondering and champing at the bit for a third installment. It was not to be. By 1970, the

anachronistic private eye was just too far gone to matter. The rule-breaking tough dicks were now actually *on* the force. Of course, I'm talking about *Dirty Harry, Hustle* and other 1970s thrillers (ironically, in a show of WTF could they have been thinking, Sinatra and John Wayne were initially offered *Harry*).

I gotta say, though, as much as I keep Tony Rome high on my guilty pleasure list, I'm sorta glad there wasn't a third chapter. Alas, by the Watergate Era, the toups were getting worse, the waistline fuller. Not a good combination. That said, I kinda wonder what Tony Rome would be up to today. I envision him residing in a second-rate Florida retirement home, using the computer work stations in the library to engage in online gambling...with the usual outcome. I can practically hear him sneering with glee, "Try and collect, you bastards! I'm 103 fucking years old!" An internet virus pox on them all.

TONY ROME/LADY IN CEMENT. *Color. Widescreen [2.35:1; 1080p High Definition]; 1.0 DTS-HA MA. Twilight Time/20th Century-Fox Home Entertainment. CAT # TWILIGHT234-BR.*

Limited Edition of 3000. Available exclusively through Screen Archives Entertainment www.screenarchives.com and www.twilighttimemovies.com

IF IT'S TUESDAY, THIS MUST BE BELLEVUE

The only thing more freakishly fun than a Tony Perkins psycho movie is a Tony Perkins psycho movie where there's someone crazier than he is. Such is the glorious case with 1968's cult classic **PRETTY POISON**, now available in a stunning limited edition Blu-Ray from the inmates at Twilight Time/20th Century-Fox Home Entertainment.

Perkins plays Dennis Pitt, a moderately (conservatively speaking) disturbed loner, who is released from an institution, where he has been incarcerated for setting a fire that (possibly, intentionally) caused fatalities. Mr. Azenauer, his weary, beleaguered case worker (the wonderful John Randolph) is a near-ninnyhammer himself,

trying to help the obviously intelligent Pitt stay focused. Among other things, Dennis is a rabid conspiracy theorist; to this end, he has created a false identity for himself – that of a secret agent, out to save America, whether they want it or not. "Cut that out, Dennis!," shouts Azenauer in a way only a Jack Benny fan could love.

The strangely bizarre thing about Pitt's fixations is the fact that they comprise enemy foreign powers infiltrating our political and industrial systems. And that our country's chemical companies, unless monitored, will pollute and contaminate our environment. How crazy is THAT?!

This isn't salved by Randolph's character getting Perkins a gig at a rural New England chemical plant, where Dennis Pitt's alter ego goes into full swing mode.

But, alas, as we mentioned earlier, Tony Perkins is not the main loony here. Enter gorgeous teen queen Sue Ann Stepanek (Tuesday Weld in the finest of her many fine cinematic moments). An impressionable high-school senior, Sue Ann instantly falls for Dennis's line, comprising his

mysterious habits, his kooky demeanor – and then, for Dennis himself. The feeling is mutual. She begs Dennis to be included in his latest surveillance mission – to save the planet from a myriad of enemies. Dennis's constant warnings of danger only excite the pubescent female whose sexuality overlaps/blossoms into full-blown orgasmic (pretty) poison ivy. This culminates with the two lovers merrily skipping down the psychopath into the abyss of nightmarish fantasy, and, ultimately, murder.

You see, Dennis, is essentially a functioning member of society. When his spewing lunacy gets to the danger level, he levels off, like when they tell Robby the Robot to kill someone. Sue Ann, on the other hand, can't stop the music and goes into zeal-n-squeal delirium when the going gets tough. Without hesitation, she kills a night watchman during the pair's nocturnal stakeout of Pitt's workplace. "He is sure is bleeding, isn't he?," she excitedly announces, barely suppressing a giggle . Dennis is a bit shocked. But to Sue Ann, it's just one of life's many "problems" to be dealt with, another being her strict single mom (an excellent supporting role for Beverly Garland).

Which she does, point blank. In a quantum universe, Sue Ann Stepanek's wallet didn't have Rhoda Penmark's picture in it; Rhoda Penmark had Sue Ann's.

Dennis, by this juncture, truly can no longer define reality, half-heartedly telling his now-dominant girlfiend, "Boy, what a week. I met you on Monday, fell in love with you on Tuesday... Thursday, we killed a guy together. How about that for a crazy week, Sue Ann?" Newly orphaned Stepanek's facing the world with eager lip-biting writhing anticipation remains one of cinema's all-time unnerving endings.

PRETTY POISON was a runaway critical smash in 1968, earning deserved kudos for the cast and director Noel Black (the name whose irony should not be discounted). Released by 20th Century-Fox, it became the primo art-house sensation of the season during its brief run (today the $1.8M pic would undoubtedly have been handled via the studio's Fox Searchlight indie arm). The picture racked up two nods from the New York Film Critics Circle, including a win for Lorenzo Semple, Jr.'s terrific screenplay (based on a story by

Stephen Geller) and a Best Actress nom for Weld's creepy, frightening evocation of Sue Ann.

Curiously, it's Weld's *least* favorite role. In fact, she despises the movie with a vengeance. ("My worst performance!"). This hatred stems mostly from her actual loathing for director Black. An acquaintance of mine once met Weld, and asked her about **POISON**, a movie he particularly was fond of. She shook her head, rolled her eyes, and responded, "Noel Black, there's a guy who could simply say 'Good morning.' and fuck up my whole day!"

Coupled with Perkins's penchant for being notoriously strange (Betsy Palmer once told me that during the location work for *The Tin Star*, she spied Perkins crawling under producers' William Perlberg and George Seaton's trailer. "What are you doing, Tony?" she inquired. Perkins shushed her, and replied, "If you get right to the center, you can hear everything they're saying about you." "But what if they're NOT saying anything about you?" the actress countered. "THAT'S why you have to listen!"), it must have indeed been an interesting shoot.

I vividly recall a 1968 conversation with a classmate of mine, who had just seen the movie with his parents. "Does this guy ever do anything else BUT *Psycho*?" "Yeah, he does," I said. "Check out some of his earlier movies." He told me he would, indicating there was one airing that night on TV. Didn't help. It was *Fear Strikes Out*.

The Twilight Time Blu-Ray of **PRETTY POISON** is a revelation. I say that for a good reason. In 1968 (and subsequently), every print of this movie I saw was gritty-looking, with the cast resembling human Bar-B-Que Chips amidst golf-ball-sized grainy compositions that redefined ugly cinematography (Pallor by DeLuxe).

The work of d.p. David L. Quaid has been beautifully vindicated in this fresh widescreen 1080p transfer. The colors are clean and clear, nicely showcasing the Great Barrington, MA, locations and with (for a change) realistic flesh tones.

Twilight Time has also gone the distance to make this the quintessential edition of **PRETTY POISON**, offering audio commentary with producer Lawrence Turman and film historians

Lem Dobbs and Nick Redman, plus an archival supplementary track featuring Black, who died in 2014. There's also a deleted scene script, the theatrical trailer, and, as with all Twilight titles, an isolated music option featuring Johnny Mandel's score.

PRETTY POISON is a movie that improves with age, and remains a startling reminder of how damn good an actress Weld can be. A kind of Harley Quinn take on her Barbara Ann role in *Lord Love a Duck* (another 1960s Weld movie I worship), Tuesday's Sue Ann Stepanek is that spoonful of sugar that helps the "problem solving" meds go down...forever.

PRETTY POISON. *Color. Widescreen [1.85:1; 1080p High Definition]; 1.0 DTS-HD MA. Twilight Time/20th Century-Fox Home Entertainment. CAT # TWILIGHT251-BR.*

Limited Edition of 3000. Available exclusively through Screen Archives Entertainment www.screenarchives.com and www.twilighttimemovies.com

UNSTABLE CONSTABLE

The fantastic, paradoxical world of Takeshi "Beat" Kitano has never been more eloquently (and cinematically) depicted than in his 1997 masterpiece **HANA-BI** (*Fireworks*), now in its long-anticipated American Blu-Ray debut from Film Movement Classics.

Kitano, a true auteur, wrote, directed, stars in and coedited this neo-noir epic of a quietly violent cop gone rogue, but for all the right reasons.

Beat is Yoshitaka Nishi, a top detective in an elite Japanese police squadron, whose specialty is cracking drug cases, hard cases and cold cases, with a sideline in felon's heads (to quote his associates: "When Mr. Nishi lost it, he was even more frightening [than the Yakuza]"). His recent life has been a train wreck, as his loyal BFF partner Horibe (Ren Osugi) sympathetically bemoans. Nishi's child died young, forever draining his positive emotional vent, left hanging by a thread due to his loving wife, Miyuki (Kayoko Kishimoto). Then, she is diagnosed with inoperable leukemia,

and confined to a nightmarish ward in a local hospital.

Nishi leaves the force due to a detention incident gone horribly wrong, which at least allows him to spend as much time as he can with his mate, while Horibe carries on. The former partner considers himself the lucky one of the pair, happily wed to a healthy, adoring wife and father to a devoted family. Then a stakeout/bust goes south, and Horibe is paralyzed. Forced to care for her now-invalid husband, Mrs. H takes the only option she deems viable. She leaves the wretch to fend for himself, moving out with their children. Ain't life a bitch? Horibe, now in as deep a depression as Nishi, contemplates suicide, but prolongs it just long enough to discover art, and begins painting a series of extraordinary canvasses.

Meanwhile, Nishi hasn't been resting on his laurels. When his wife's lead surgeon suggests that her final days might be more pleasant at home, the stoic detective takes the advice and plans to move his near-vegetative love from the sterile, depressing surroundings.

Nishi recalls the wonderful trips the family used to have; and from there appears the acorn from which mighty oaks grow. He plans a bank heist, in part to payback a loan he took from the Yakuza, hoping the robbery will be blamed on the local mob contingent, and using the leftover money to give his beloved wife the time of her life.

The subsequent onslaught is quite sanguine, but does succeed, and the Nishis drive off for their dream vacation. And the effects are startling. Mrs. Nishi begins to laugh again, the lethal symptoms temporarily replaced by genuine happiness. This changes Nishi's demeanor too, and the couple enjoys what precious time they have together, carrying on like newlyweds. A key moment, ergo the title, comes when the Nishis view a fireworks display. The fireworks literally define the title, but also the explosions of emotions, color (from their formerly bleak existence) and job-related physical ferocity. Like the narrative, **HANA-BI**, in toto, carries a complex, multi-leveled meaning.

That the Yakuza, along with the police, eventually converge on the dirty cop and his unsuspecting

wife brings yet more fireworks and a volatile, yet touching climax.

Suffice to say, **HANA-BI** is unlike any movie you have ever seen. It is a moving, spiritual drama, a sensitive love story and a savage crime pic all rolled into one. And the damn thing works. It's as if Kitano has been channeling Kurosawa at various stages of the famed iconic director's career. As such, **HANA-BI** is a seamless hybrid of *Ikiru* and *High and Low* (with a generous sprinkling of *Throne of Blood*). Even with its raging brutality, **HANA-BI** is truly one of the most beautiful movies of the past twenty-five years.

Aside from the terrific acting by the principals and directing, Kitano has stacked the deck with luxurious color cinematography that is almost Sirkian (kudos to Hideo Yamamoto). In addition, a major portion of the movie's triumph is the brilliant score by Joe Hisaishi. Rather than go for the usual by-the-numbers churning crap that often passes for movie music these days, Hisaishi has embellished this celluloid poem with a melodious, lush composition reminiscent of a late-1950s work by Hugo Friedhofer or Franz

Waxman or Alfred Newman. The music is gorgeous. I cannot finish this article without commenting on the superb editing of **HANA-BI** (as indicated, a task Beat shared with Yoshinori Ota). Even the solemn and serene, gentle moments contain a quivering sense of foreboding tension. I've rarely experienced anything like it.

A footnote: Kitano's wearing of many hats took its toll several years ago when he suffered a near-fatal heart attack. While convalescing, Beat, like Horibe, took up painting. Many of the results are the remarkable tableaus that dot the backgrounds of **HANA-BI**. I'm tellin' ya, this guy can do no wrong.

Film Movement's Blu-Ray of **HANA-BI** is outstanding, crystal-clear ebullient rainbow imagery matched by a dynamic stereo-surround track (particularly the bass which will kickass-test your audio system like a muthafucka). If that's not enough, there are some enticing extras, including audio commentary from *Rolling Stone* critic David Fear, a making-of featurette and a beautifully illustrated booklet. This one's a keeper!

HANA-BI. *Color. Widescreen [1.85:1; 1080p High Definition]; 5.0 DTS-HD MA (Japanese w/English subtitles). Film Movement Classics.*

Die Laughing Addendum

BOB "DOUBLE INDEMNITY" HOPE

Sad that the American screen comedies of Bob Hope have gotten a bit tarnished as of late, as they remain an integral part of 20th-century laff cinema. Hope's movies pretty much defined the 1940s and essentially changed the direction of Hollywood comedy. The comedian's rapid-fire retorts, often directed at the audience as much as the characters on the screen, his anachronistic asides in the period pieces that so delighted and influenced Woody Allen (and a slew of others who followed his clown-sized footsteps), the often surreal involvement of talking animals and inanimate objects – all of that had been so expertly injected into the funnyman's oeuvre (that's not what you think it is – and wash your mind out with soap!) that it passed into core Americana without nearly anyone noticing (the

great critic/writer James Agee being a major exception to the rule). To be sure, when Hope threatened his Bijou villains ("You wouldn't say that if my writers were here"), it was a welcome self-deprecating jab at his not-so-secret reliance on specially prepared ad libs for all occasions. Prime to Hope's (and Crosby's) gift of the sharp retort was the generally unheralded input from a bona fide comedy genius, Barney Dean. Dean essentially created the Hope persona, and, in doing so, revolutionized movie comedy writing to a delirious and inspired level that contemporaries still steal...ummm, pay homage to. If I were more ambitious, I would embark on a book-length bio of Dean – a noble but futile quest, as his anonymity guarantees a readership of nil.

It's been so long that the Hope pics have gotten regular play (a TV staple throughout the 1960s-70s) that they're almost a whole new sub-genre. Bob Hope, who when not rolling 'em in the aisles on radio, television, in pictures and live on hot battlefield stations across the globe, was a shrewd businessman. This is important to mention, as by the mid-1940s, he renegotiated his deal with Paramount to allow him to produce his own

popcorn-friendly products that would be released under the Zukor firm's arm. These titles would eventually totally revert back to the comedian, giving him sole re-issue/TV rights. On-screen cohort Bing Crosby likewise followed suit (they co-produced the Road pics after the 1946 blockbuster *Road to Utopia* under the dual auspices of Hope Enterprises and Bing Crosby Enterprises).

And there lay the rub. Someone at the comic's legal firm was asleep at the wheel, and several of the titles went "gray," or pseudo-public domain, while one went full-blown p.d. That outing, **MY FAVORITE BRUNETTE**, one of Hope's finest, became a notorious renegade entry due to decades of lousy bootlegs that flooded the home-video market via negligible VHS tapes, laserdiscs and DVDs.

Thanks to Kino-Lorber/Fremantle Media, Ltd., there's a breath of fresh air in movie-platter heaven, as collectors can now safely rediscover these frequently riotous gems in excellent-to-stunning Blu-Ray evocations, mastered from the

best surviving 35MM materials reportedly gleaned from the entertainer's estate.

1947's **MY FAVORITE BRUNETTE** is an extraordinary movie on so many levels. For one thing, it is probably the most perfect film noir spoof of all time. What makes it even more remarkable is that it sparklingly parodied a genre while it was happening and flourishing! The writers (Edmund Beloin, Jack Rose, and uncredited assist from the aforementioned Barney Dean and Hope himself) outdid themselves, bullseye-targeting all the quirks, foibles and trademark characteristics of the mean-streets scenario: the mysterious mansions, the exotic Americana locales, the slick, wet, nocturnal pavements and, best of all (for Hope fans), the hard-hitting, sarcastic voice-over narration: "I had a lump on my head the size of my head," monotones Hope's character – Ronnie Jackson, a baby photographer who yearns to be a private eye like his heroes Alan Ladd, Humphrey Bogart and Dick Powell.

Being that this is a Paramount Picture, the real detective in Ronnie's office building (Sam McCloud) is none-other THAN Ladd, in a hilarious

cameo bit. Of course, the femme fatale (Dorothy Lamour, always underrated and thoroughly zeroing in on the dangerous female role, mistakes Jackson for McCloud and, thus begins a merry adventure that effortlessly incorporates Raymond Chandler into a Looney Tune world of intrigue, gunsels, thugs and mugs. The main sinister plotline is so incredibly close to that of Goldwyn's *Secret Life of Walter Mitty* (released the same year) that it's astounding lawsuits weren't flung around with as much panache as the deadly daggers thrown by Peter Lorre in this pic. Aside from Lorre, the cast is a Who's Who of noir, and includes Lon Chaney, Jr., Charles Dingle, Jack LaRue, John Hoyt, Anthony Caruso and Ray Teal.

It's futile to quote the reams of memorable laff lines, as **BRUNETTE** is chock full of 'em, but one never fails to slay me. Hope, on a midnight run for his life from the evil pursuers, dodges into an apartment building and immediately begins ringing all the doorbells, crying out, "It's Joe," figuring SOMEONE knows a Joe. The response is outrageous – a cacophony of horny women, moaning "Come in, Joe," as all the buzzers sound.

Hope's response and delivery, "I must remember this address," is priceless.

The ending, where Hope's character walks his last mile to the electric chair is another pip, and features a final riotous guest star.

MY FAVORITE BRUNETTE is unquestionably a favorite for Hope fans (easily the apex of the "My Favorite" series – the other entries being *Blonde* Madeleine Carroll and *Spy* Hedy Lamarr). It's no surprise that noir buffs love this movie, since, as indicated, it hits all the right bases and ultimately scores a comic home run. The direction beautifully mixes suspense with guffaws, a credit to Elliott Nugent, who had previously guided Hope through two box-office smashes, *The Cat and the Canary* (1939) and *Nothing but the Truth* (1941).

For years **BRUNETTE** was a thorn in movie collectors' sides, being that this title was only accessible in wretched, duped editions. This 35MM transfer, while a bit grainy, is nevertheless a revelation, at last doing justice to Lionel Lindon's silky monochrome photography. The music by Robert Emmett Dolan captures the feel

220

of the real deal, and even includes a suitable torch song, "Beside You" (by Jay Livingston and Ray Evans), ably warbled by Lamour.

MY FAVORITE BRUNETTE . *Black and white. Full frame [1.33:1; 1080p High Definition] 2.0 DTS-HD MA. Kino-Lorber Studio Classics/Fremantle Entertainment/Hope Enterprises. CAT # K21600.*

JERRY NOIR

Many of the supreme delights of the ongoing Olive Films/Paramount Home Video series encompass the inclusion of the relatively erratic/oddball titles from the studio's vault. While 1962's **IT'S ONLY MONEY** isn't the most unknown of the hen's tooth batch, it certainly remains (up until now) the rarest of the 1960s Jerry Lewis output. It got a fairly discreet no-fanfare release in '62 and was the least talked-about of the comedian's post-Martin & Lewis works. For me, this was more than a slight because I love **IT'S ONLY MONEY**, and consider it not only one of Lewis' best flicks – but one of the top four of the eight pictures he made with Frank

Tashlin (for the record, this was the sixth – my other three faves being *Artists and Models, The Geisha Boy* and *Who's Minding the Store?*).

The movie has been sloughed off by the masses due to both its scant screenings and the "so-what?" attitude that Lewis attached to the vehicle. It was a fairly cheap project – quickly thought out, and even quicker filmed in late 1961 – sandwiched between the showy extravagant Technicolored masterpieces *The Ladies Man* and *The Nutty Professor*. **IT'S ONLY MONEY** was lensed in black and white – the last monochrome movie Lewis would ever make; however, it is the sparse look and B&W photography that ironically pushes it to the top of the great Hollywood genre spoofs.

In a nutshell (with the industry's then-prime cashew at the head), **IT'S ONLY MONEY** is a film noir parody pinpointing the plethora of private-eye sagas that flooded the big and small screens and pulp paperback racks throughout the decade following World War II. It's a movie that's perhaps is a bit too smart for its own good – complex in its seemingly simple construction as to rise way

above the craniums of the average popcorn muncher.

In Tashlin's able mitts, **IT'S ONLY MONEY**'s multi-leveled cinematic architecture targets a number of subjects, scoring a bulls-eye in each one: 1) Tashlin's animation roots; 2) classic noir; 3) 1960s noir; 4) modern-day technology. All of these intertwine like the non-disclosed tentacles of Citizens United.

Jerry portrays Lester March, an orphan who ekes out his existence as a TV repairman. Television is the paradigmatic theme, as the movie's noir trappings specifically zero in on the country's obsession with the detective tele-series, primarily *Peter Gunn*. Lester's idol is Pete Flint, a suave babe-magnet gumshoe, hilariously enacted by the couldn't-be-more-opposite Jesse White. Donning a trench coat and fedora and living out of his office of booze-filled file cabinets, Flint is a sleazeball, who eventually gloms on to the fact that Lewis is heir to a mega-million dollar fortune left by the murdered "founder of TV." It's absolutely the greatest of White's many memorable roles.

Jerry's character is the most-animated of any of his movie portrayals (and think about that); **IT'S ONLY MONEY** is, succinctly-put, Lewis at his most cartoonish. This beautifully connects to Tashlin's origins as an illustrator and key director of the famed Warner Bros. Looney Tunes division. Indeed, there are many references to some of Tash's and Termite Terrace roomie Chuck Jones' prime WB efforts, prominently the forays into the gadget-laden House of Tomorrow entries which surfaced in such classics as Jones' *Dog Gone Modern* (1939), Tex Avery's 1949 MGM short, appropriately entitled *The House of Tomorrow*, and, later, in the live-action Tashlin-scripted prop-posterous finales of the Red Skelton and Lucille Ball comedies *The Fulller Brush Man* and *The Fuller Brush Girl* (1948 and 1950).

Additional cartoon connections come from the cast: as Lewis' poor-little-rich girl niece Mae Questel, the screen's immortal voice of Betty Boop, is outstanding, especially when attempting yoga exercises to slim down for her wedding to slimy lawyer-villain Zachary Scott. Scott, in his final performance, provides a casting *tour de*

farce, magnificently satirizing his legendary sinister stints from 1944's *The Mask of Dimitrios* and 1945's *Mildred Pierce* (tossing this gig to a comic specialist like Harvey Korman probably would have worked, but nowhere near as effectively). Scott's participation was a stroke of genius; it sadly also demonstrates how Hollywood did the actor dirt by not giving him more comedy to do. LST, he's pretty damn funny! Scott's moron henchman is Jack Weston, a self-proclaimed charter member of the Peter Lorre Fan Club, who revels in terrorizing a roast with an icepick. The violence and killings are particularly shocking for a supposedly kids-oriented movie, but, then again, this was a done-on-the-cheap knock-off – so Paramount haphazardly looked the other way; for them (as with its creators), **IT'S ONLY MONEY** was part of a Jerry Lewis quota needed (as with their Elvis Presley pics) to fill the studio's annual schedule.

The va-va-vroom factor is ably filled by the sleek-bodied Joan O'Brien as the luscious mysterious nurse who soon suspects foul play and may (or may not) be falling in love with Lewis. Even her name, Wanda Paxton, is quintessential *femme*

fatale noir. Tashlin directs her entrances via askew comic book panel angles, pulling back from her amazing legs running down steps and high heels clicking off wet pavement mean streets.

An early sequence wherein Lewis pretends to be White is hilariously sabotaged by the arrival of client/man-eater Pat Dahl, who simultaneously terrifies/arouses Jerry into freak-out mode. Her maneuvering him into a corner is nothing less than a dry hump, rubbing the frightened impersonator up against a water cooler, which starts to steam boil to furious crescendo – visually far more sexually explicit than anything in Stanley Kubrick's *Lolita*, released the same year.

Similarly, Jerry's near-death encounters are as funny as they are cruel, often involving some fantastic screen denizens like Barbara Pepper as a butch fisherwoman who inadvertently saves Lester's life and whose livelihood Lewis all but ruins. Another noir nod is the appearance of famed heavy Ted de Corsia as an investigating cop.
Lewis' clash with technological innovations culminates in the Merrie Melodie climax where,

pursued by man-eating lawnmowers, he triumphs in a Tashlinesque victory that surely would have delighted Jacques Tati (or any other Frenchman). The comedian's obsession with outlandish high-tech wizardry isn't that far-out today, as **IT'S ONLY MONEY** hovers around such crazy gadgets as large widescreen interactive TVs and iPhone-like visual communication devices. Of course, with the possible exception of Robert Durst, what affluent one-per-center would ever hire Jerry Lewis to fix their television? This riddle for the ages is brutally answered by the aforementioned White, who painfully is the pic's receiving end of a barrage of sight gags – the zenith (no pun) being the astronaut helmet crowning with a portable TV unit.

While much of the credit for **IT'S ONLY MONEY's** success belongs to screenwriter John Fenton Murray (who would go on to pen the underrated Howard Hawks comedy *Man's Favorite Sport?*), the lion's share of the verbal laughs are the obvious contributions of the director and the star. Some of Jerry's greatest malapropisms abound during the course of the picture. Lewis' Mickey Spillane/TV detective slang is bitch-slapped out of

him by an irritated White, who demands that he stop with "...the idiot television talk." Jerry admittedly can't help himself, proclaiming that "I'm a TV thing." When threatened by Scott's and Weston's Smith and Wessons, Lewis pleads, "I'm too tall to hurt!" Lester's referring to would-be paramour Wanda's profession as "...a sick pill or medicine betters" is enough to bring tears to Shakespeare's eyes (or any other semi-literate). Furthermore, his stunning declaration of "You made my living life no death" is pure gold (well,... maybe Goldwyn), delivered with the assuredness of Barrymore at his peak (John Drew, that is). Astoundingly, Lewis' discussion of his love of cats with girlfriend O'Brien (resulting in being nicknamed Lester "Pussy" March) made it by the censors.

Scenes of Jerry immersed in a giant fish head or sticking a soldering iron up his nose constitute vintage Lewis, the stuff we'd love to have seen the likes of Warren Beatty or Robert Redford do on-camera and secretly suspect Mel Gibson does do off-camera. These outrageous Jerry-rigged moments are sledge hammer-subtly appended by brick-wall product placement exteriors featuring

one-sheets of the comedian's previous cinematic outings, such as *The Geisha Boy* and *The Errand Boy*. The slick score by Walter Scharf is another plus, perfectly Henry Mancini-ing it to the gills with jazzy *Peter Gunn* consonance (although the frugal 83-minute running time may explain the Bobby Van-credited musical numbers – of which there are none). The B&W W. Wallace Kelly photography is aces, admirably providing the necessary hard-boiled look (although the occasional faux close-ups of originally-shot blown-up two shots really show through on Blu Ray). In general, the Olive Films Blu-Ray is excellent: a near pristine 35mm crystal-clear transfer, which the mono audio ideally compliments.

As earlier indicated, despite its obscurity, this movie is one of the consummate achievements in the Jerry Lewis-Frank Tashlin canon; it's also one of the Lewis titles that the comic's legions of non-fans begrudgingly admit to liking. So open up your wallets and take a chance...after all, it's only... (no, I can't bear to even say it)...

IT'S ONLY MONEY. *Black and White. Letterboxed [1.85:1; 1080p High Definition]; CAT# OF360.*

ACKNOWLEDGMENTS

I was genuinely touched by the thoughtful and even loving tribute given to me in the foreword by Cardinal Content, publishers of **NOIR VOYAGER**, hopefully our first of a series of movie anthologies, geared toward the Blu-Ray and DVD collector.

I feel it necessary to put a human face on Cardinal, aka the prolific and incredibly talented Alan Diede. Alan, an old college chum of mine (sadly, these days, all college chums are old) first approached me to go in this direction years ago. I finally relented, mostly at the urging of many important folks in my life, some who threatened violence if I refused.

Aside from Alan, who BTW, was the director of the now tragically lost *Behind the Scenes*, the best student film EVER made, I was pushed, prodded and shamed by my very significant other, wife Angela, who has been my guiding light for over twenty years; I would definitely no longer be here if it wasn't for Angela. So blame her.

Many participants within the industry have asked if I'd ever consider a book (some have done endorsement blurbs in this volume), including the great and hilarious Eve Golden, Marlyn Mason, Sylvia Lewis, Sherry Jackson, Will Hutchins, Monika Henreid, Glyn Baker, the late Harry Carey, Jr., and the late Betsy Palmer. Long departed souls who encouraged me in my soot and furnished the many sideline anecdotes that dot my scribbles include Otto Preminger, Robert Clampett, Nicholas Ray, Desi Arnaz, Peter Cushing, Ingrid Pitt, Aldo Ray, Paul Picerni, Curtis Harrrington, Douglas Sirk, Trevor Howard and Mel Blanc. How'd ya like to have them all at one party? Can't deny a nod to the wonderful folks at the home video/PR companies who continually had/have had faith in me, primarily Brian Jamieson, Julie Kirgo, the late Nick Redman, Frank Tarzi, Matt Barry, Bradley Powell, Marie Remelius, Michael Krause, and Lauren Wynne.

No list could be complete without mentioning the brilliant screenwriter/director and bestest friend one could ever hope for, the late Ric Menello, perennially growling at me, in his patented mock anger, to "WRITE A FUCKING BOOK ALREADY"

(Ric's favorite piece of mine was *The Big Heat* article, included in these pages; he had it bookmarked on his laptop and read it at least twice a month)! Menello and I spent 42 years watching movies together (at least once weekly), writing scripts, treatments and making little indie shorts. I hoped to enter doddering, dithering decrepitude with Ric, shaking and barely coherently announcing (between gaping oxygen tank breaths), "They've put *Greed* on Blu-Ray!" Another never-to-be exit. Suffice to say, Ric, I still can't watch a movie – ANY movie – without imagining you there, laughing and commenting throughout each platter, exhibiting your pure love and joy for cinema.

Last, but certainly not least, there's Christa Lang-Fuller, who graciously wrote the introduction to this tome. Christa has been Lady Goddess to me since I first saw her stealthily glide across the screen in *Dead Pigeon on Beethoven Street*, back in 1973. I can never compliment her enough for her skills as a thespian, producer, writer and even her parenting. Proof that it's in the genes is generously evident via her daughter, Samantha, the auteur of *A Fuller Life* (based on papa Sam

Fuller's autobiography *A Third Face: My Tale of Writing, Fighting and Filmmaking*), in my opinion, one of the best feature documentaries on the movies ever made. I encourage every Fuller fan, film noir enthusiast, and docu buff to seek it out pronto. I mention it in the Fuller-devoted section, but also want to give readers an additional thumbs-up. The Blu-Ray/DVD is available through The Criterion Collection (as a supplement for *Forty Guns*, fer Christ's sake!) and/or through their streaming service, as well as on iTunes.

Fade to black.

Mel Neuhaus,
June 2019

ABOUT THE AUTHOR

MEL NEUHAUS has been writing, rhapsodizing, ranting and, admittedly, bitching about cinema since the flickering images of Million Dollar Movie flashed across his family's 21-inch black-and-white RCA, back in the early 1960s. It was love at first sight (didn't hurt that both his parents were addicted to celluloid). For the past 35 years, he has been writing about motion pictures for such publications as *Video, Video Review, Sound and Vision, The Perfect Vision* and scores of others. An award-winning director of several shorts, Mel was additionally one of Nicholas Ray's associate editors on the famed director's final project, the thoroughly weird and often downright crazy-ass *You Can't Go Home Again* (the post-production of which deserves its own book). Mel is also the writer and co-writer of TWO unfilmed screenplays that grace the Coolest Movies Never Made list.

Made in the USA
Middletown, DE
15 September 2019